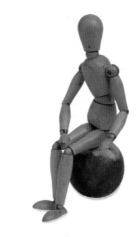

Body Parts

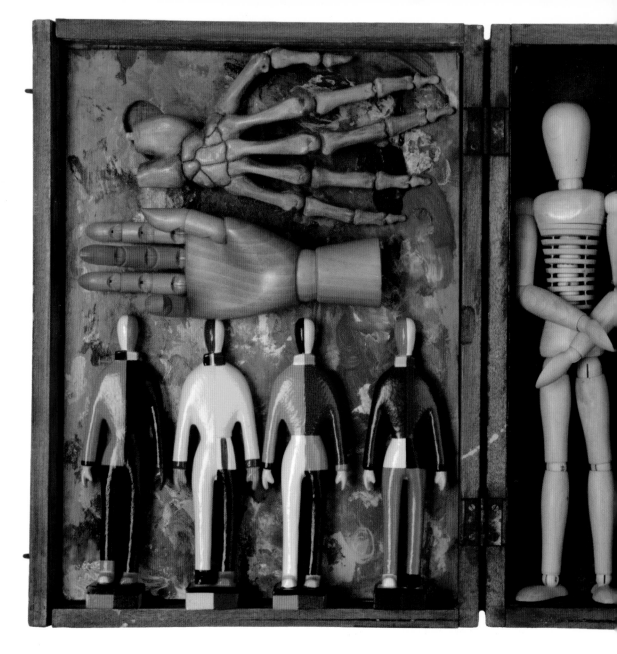

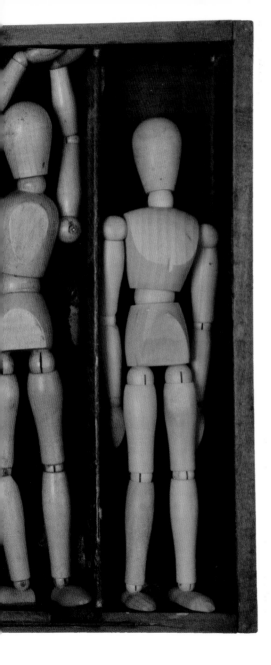

Body Parts

A visual sourcebook for drawing the human body

General Editor Simon Jennings

NORTH LIGHT BOOKS
CINCINNATI, OHIO
www.artistsnetwork.com

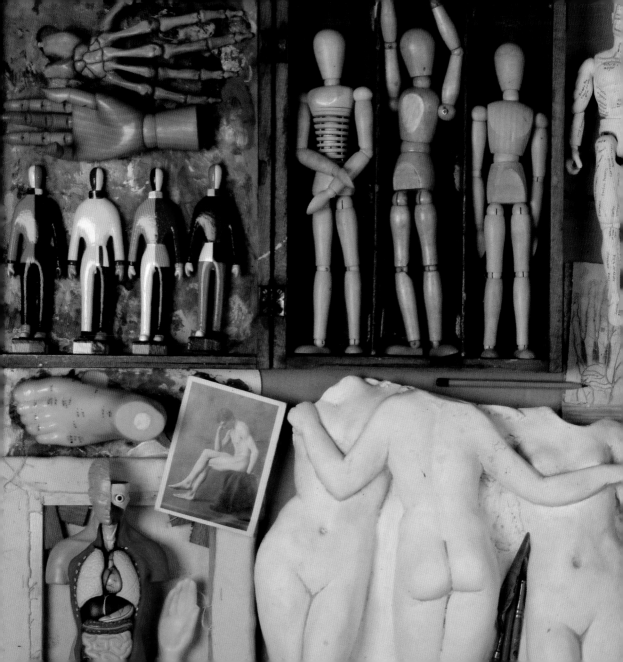

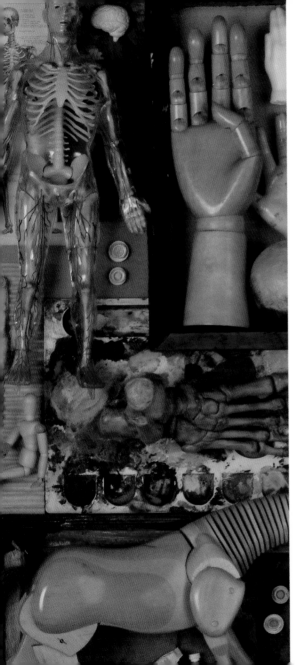

Contents

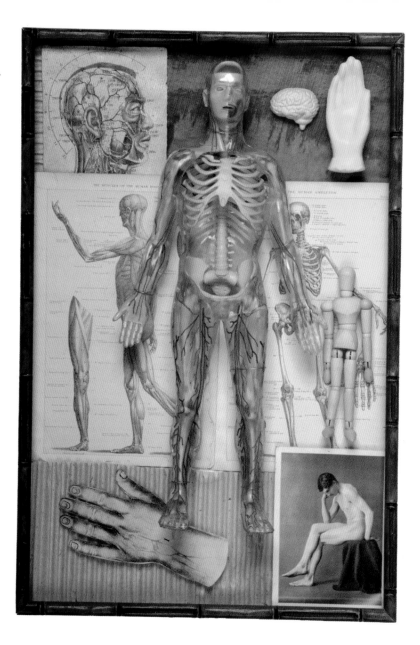

The infinite variety of humanity is a vast resource for the artist, who, as drawing and painting are legitimate reasons for looking closely at people, stands in a place of special privilege. Without observation and the gathering of genuine evidence, an artist will only be able to produce generalities from memory, and these drawings and paintings are often unconvincing.

Only by looking with the naked eye can you select the necessary composition, emphasis, and information to make your drawings a plausible rendering of what you have seen. For the beginner, there is also a mental barrier to break around figure drawing, since there may be inhibitions about staring hard at other people, and anxieties about our ability to catch a tolerable likeness that will not offend another human being. Furthermore, the person you are drawing is quite likely to move frequently, if not all the time, unless he or she is a professional artists' model!

The answers to these difficulties lie in accepting that artists are generally held in affection and esteem by society, and the task of recording what is seen, and sharing that vision with others, is a respected one. Others may experience or express disappointment in relation to their expectations of your work, but they will not expect a professional result if it is understood that you are at the start of your artistic career. Lastly, do not be too hard on your results - acknowledge your successes when they come.

the human machine

10 Anatomy for the artist

Anatomical knowledge for the artist relates to understanding and depicting the three-dimensional form of the body that lies beneath the skin.

The basic shape of the human body is based on the vertically symmetrical pattern of the skeleton. This internal scaffolding is intricately jointed to enable the body to move freely, and it is important to remember that the framework of the living, moving body never holds the limp poses of the cadavers that are studied by medical students. The surface figure that we draw is dictated by the muscular structure that covers the majority of the skeleton.

Muscles control our every movement, in direct response to nervous messages sent along them from the brain. Variations in

external body shape, whether small or large, often relate directly to the basic bone-and-muscle structure. As with all visual work, you should observe each individual subject closely, because bodily proportions and dimensions vary from person to person, even before considerations of age and gender are taken into account.

The best way to put anatomical knowledge to practical, artistic use is to attend a life-drawing class or session, where you can observe how poses are created and made possible by different muscles and bones. Drawing from life is examined in detail later in this book, but a basic understanding of anatomy will make even the roughest sketches and studies more accurate and true to observation.

Machine, power station, computer | 11

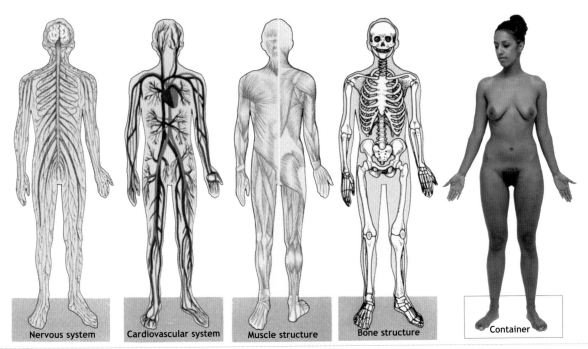

| Nervous system | Cardiovascular system | Muscle structure | Bone structure | Container |

The human machine
Packed into the human form is a sophisticated integrated system, all of which is operated via an information network that would need the most powerful of computers to reproduce.

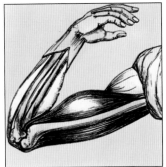

Concerns of the artist
The artist is concerned with the outward appearance. The bones and muscles within the container of flesh influence this outward appearance and contribute to the amazing individuality and variety of the human form.

12 Skeleton and bone structure

The bones form the internal scaffolding of the human body. These drawings show how the skeleton fits inside the overlying muscles and soft tissues.

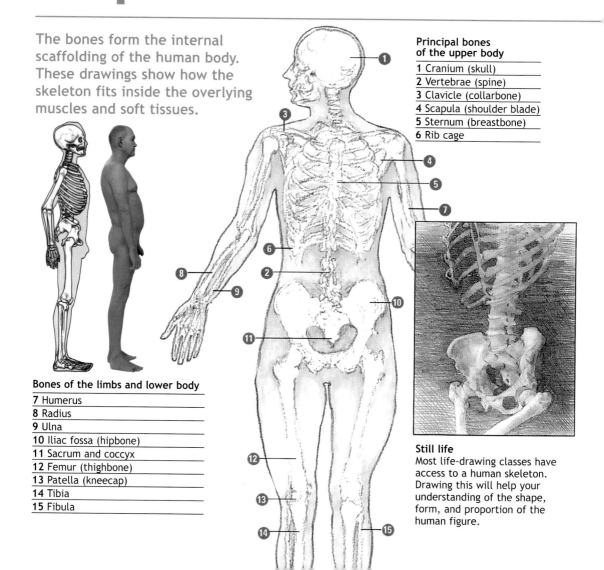

Principal bones of the upper body

1 Cranium (skull)
2 Vertebrae (spine)
3 Clavicle (collarbone)
4 Scapula (shoulder blade)
5 Sternum (breastbone)
6 Rib cage

Bones of the limbs and lower body

7 Humerus
8 Radius
9 Ulna
10 Iliac fossa (hipbone)
11 Sacrum and coccyx
12 Femur (thighbone)
13 Patella (kneecap)
14 Tibia
15 Fibula

Still life
Most life-drawing classes have access to a human skeleton. Drawing this will help your understanding of the shape, form, and proportion of the human figure.

Muscles and physique | 13

Main muscles of the back, neck and trunk

1 Splenius capitis
2 Rhomboideus major
3 Trapezius
4 Deltoid
5 Latissimus dorsi
6 Thoracolumbar fascia
7 Gluteus maximus

The musculature of the human body forms the upholstery, or padding, and varies enormously from person to person. Some muscles change shape a great deal when put to use, and the amount and distribution of fatty tissue also determine the shape of each individual body.

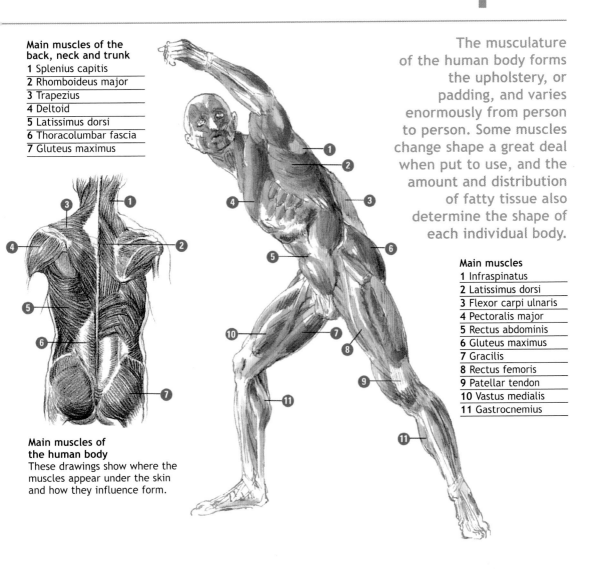

Main muscles of the human body
These drawings show where the muscles appear under the skin and how they influence form.

Main muscles

1 Infraspinatus
2 Latissimus dorsi
3 Flexor carpi ulnaris
4 Pectoralis major
5 Rectus abdominis
6 Gluteus maximus
7 Gracilis
8 Rectus femoris
9 Patellar tendon
10 Vastus medialis
11 Gastrocnemius

The human skull has a whole range of functions beyond mere protection, all of which influence its structure and proportions. As an artist, you will find that a basic knowledge of the bones that underpin the physiognomy, and the muscles lying on top of them, will help you convey the character of any model.

The main features of the skull are the mandible, or lower jaw, and the cranium. The upper part of the cranium, called the calvaria, forms a box that encloses and protects the brain. The remainder of the skull forms the facial skeleton, of which the upper part is immovably fixed to the calvaria, and the lower part forms the freely movable mandible.

Although the skull determines the overall shape of the head, it is, in fact, the

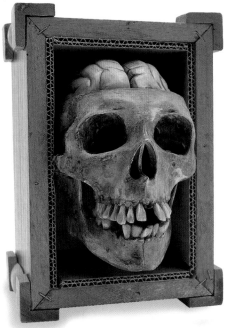

muscles that lie beneath the skin of the face, scalp, and neck that create the facial expressions that give movement and character to each individual person.

While it is helpful to be aware of the many muscles responsible for lip movements, and those that surround the cavity of each eye, the problem confronting you as a portraitist is that all this underlying structure is hidden beneath layers of hair, skin, and fleshy features. As an artist, you must rely on close observation to determine how much of what you know lies beneath the surface actually shows in the face you are drawing. The same attention to detail will enable you to record the huge range of emotions revealed by slight movements of facial muscles, and depict subtleties such as mood and temperament.

Skull shape
The outline of the skull, seen from above, varies greatly, from more or less oval to nearly circular, although its greatest width is usually closer to the rear than the front.

Orbital openings
The orbital openings in the skull contain not only the eyes but all their associated muscles.

Jawbone
It is easy to underestimate the size of the jawbone in relation to the skull as a whole.

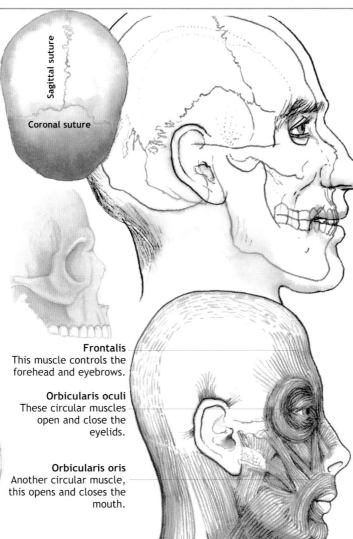

Sagittal suture

Coronal suture

Frontalis
This muscle controls the forehead and eyebrows.

Orbicularis oculi
These circular muscles open and close the eyelids.

Orbicularis oris
Another circular muscle, this opens and closes the mouth.

PARTS OF THE SKULL

• **Cranium**
This is the whole skull, less jawbone.

• **Calvaria**
This is the rounded "cap" of the skull.

• **Superciliary arch**
A bony ridge that is visible just below the eyebrows.

• **Zygomatic bone**
Also known as the cheekbone, this is most obvious in a half-profile view.

• **Mandible**
The movable lower jaw includes the chin.

16 | Anatomy of the hand

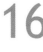

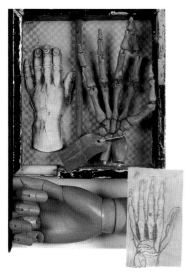

An appreciation of how the human hand is constructed will enable you to interpret what you see on the surface with greater accuracy. The hand is not simply a flat paddle adorned with a row of fingers. It is a complex matrix of bone, sinew, and muscle, operating within an elastic covering of skin.

Understanding the relationship of those parts and their range of movement is integral to conveying the effects they have on the external contours of the hand; that you, the artist, are trying to portray in two dimensions.

However, it is not slavish reproduction of correct anatomical detail that leads to successful drawing. From the fleshy hands of children and young women to the bony fingers and veined hands of old men, each hand is unique and requires close observation before you can reproduce its precise character.

As a first step, get to know your own hands intimately by drawing them from different angles. Make sketches of their general proportions, then make detailed studies of your knuckle joints, the patterns

of veins on the back of your hand, and the way the muscles bunch up as you close your fingers to make a fist. Try to imagine that those familiar hands belong to someone else so that you can be as objective as possible, and build up a visual repertoire. With practice, you will find that even a basic familiarity with your own anatomy will enable you to see beyond the superficial appearance of any hand and help you draw with greater fluency.

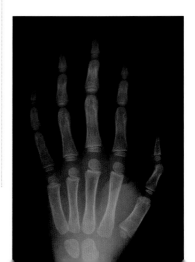

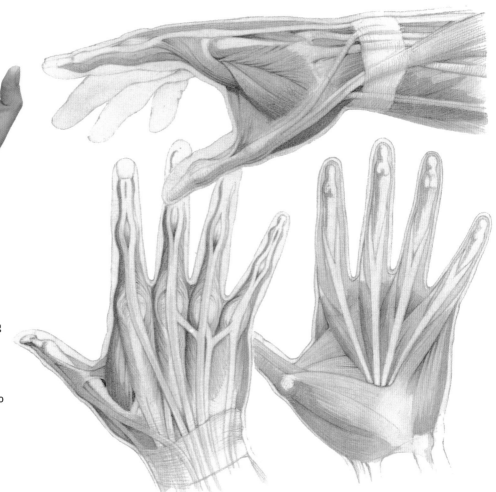

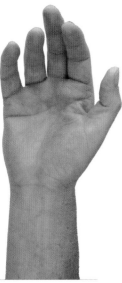

Adult hand
Palm and back of an adult hand showing underlying construction of bones, muscles, and tendons. Try to use what you know is happening beneath the skin to enable you to see clearly what is in front of you.

18 Ideal proportions

Throughout history artists have sought to create an ideal formula that can be applied to the proportions of the human body. Among the first artists to establish a general rule or standard, known as a canon, was the Greek sculptor Polyclitus. In the 5th century BC Polyclitus is known to have arrived at an ideal proportion for the human figure: he believed that a figure's height should be equivalent to seven and a half times the length of the head. This ratio has become the standard on which later artists based their studies.

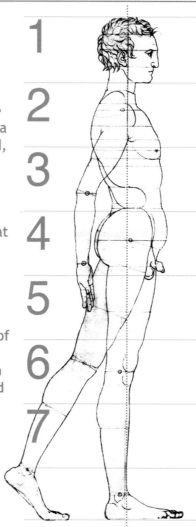

During the Renaissance many artists studied and challenged these classical proportions. Some accepted the Greek canon of seven and a half heads to one body height while others believed eight heads to be more harmonious. Leonardo da Vinci (1452-1519) believed that ten heads' height was the correct proportion. By the beginning of the 20th century eight heads high by two heads wide had become the accepted ideal.

Relative proportions ☞
Proportions vary considerably from individual to individual, but as a general rule the span of one's outstretched arms is roughly equal to one's height. The height of the model in the photograph (*right*) is exactly seven heads' height, bearing out the historic rules of average proportions.

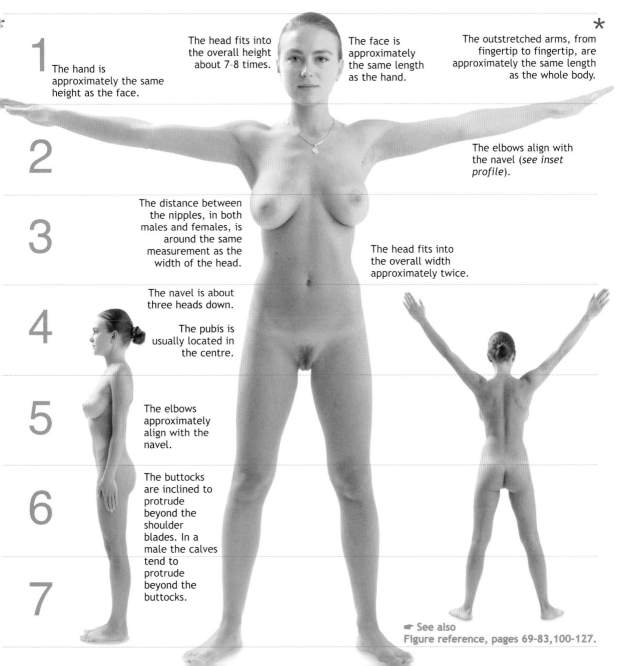

1

The hand is approximately the same height as the face.

The head fits into the overall height about 7-8 times.

The face is approximately the same length as the hand.

The outstretched arms, from fingertip to fingertip, are approximately the same length as the whole body.

*

2

The elbows align with the navel (*see inset profile*).

3

The distance between the nipples, in both males and females, is around the same measurement as the width of the head.

The head fits into the overall width approximately twice.

4

The navel is about three heads down.

The pubis is usually located in the centre.

5

The elbows approximately align with the navel.

6

The buttocks are inclined to protrude beyond the shoulder blades. In a male the calves tend to protrude beyond the buttocks.

7

☛ See also
Figure reference, pages 69-83, 100-127.

20 | Divine proportions

"The Golden Section is beyond definition and in this respect is like God."
LUCA PACIOLI, MATHEMATICIAN AND A CLOSE FRIEND OF LEONARDO DA VINCI

Since classical times artists have used a system of proportion known as the Golden Section or Golden Mean. Based on mathematical principles and the laws of nature, the Golden Section was adopted by Renaissance artists, who believed it expressed visual harmony in painting and sculpture.

Leonardo da Vinci, artist, scientist

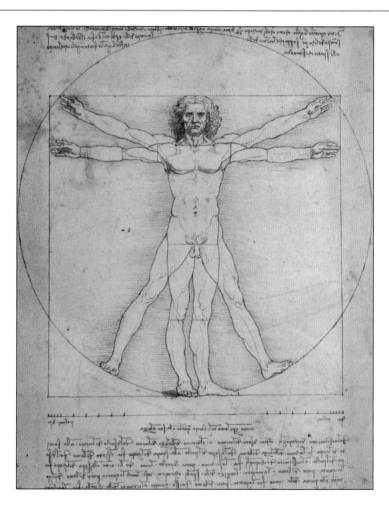

In its simplest application the formula of the Golden Section ensures that when a line is divided into two the smaller part is to the larger as the larger is to the whole. This ratio is roughly 8:13, and is expressed mathematically as 1:Φ [phi]. The division of a work of art into these proportions allows an artist to place the elements in a composition in a way that is naturally pleasing to the eye. In the drawing Vitruvian Man (left) by Leonardo da Vinci, the ratio from the top of the head to the navel, in relation from the navel to the soles of the feet, is 8:13 (approximately) or 1:Φ [phi], which is the Golden Section.

Leonardo da Vinci (1452-1519)
Vitruvian Man, c.1490
Pen, ink and watercolour
Gallerie dell'Accademia, Venice

1:Φ

The divine proportions of the Golden Section are:
1:Φ [PHI]
OR **8:13** [APPROXIMATELY]

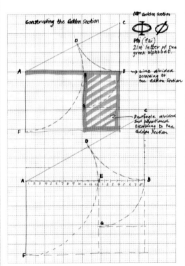

This sketch shows a rectangular area divided and proportioned according to the Golden Section.

Constructing a Golden Section is a lot simpler than it looks.

1. Decide the width or height of the area to be used for your composition, picture, or object and draw a line from A to B.

2. Draw a line which is half the length of A to B, at a right angle to point C.

3. Join point C to point A.

4. Using a compass or dividers, scribe an arc from point C to point B to intersect the line C-A at point D.

5. Scribe another arc from point A to point D to intersect line A-B at point E.

Line A-E-B is a division of 1:Φ (approximately 8:13), and is the division of a line according to the Golden Section.

6. Continue the arc through from point E to point F, which is immediately in line with point A.

7. Scribe an arc from point E to point B to create point G, from which point the rectangle can be divided.

People come in a huge range of shapes and sizes, with very different heights and body builds. Although average standard measurements can be applied, there are significant differences between one individual and another, and in the proportions of the male and female adult physique.

Body shapes
There are three broad groups of body shapes: endomorphs (heavy-set); mesomorphs (middle-ranging and often muscular); and ectomorphs (spare and lean).

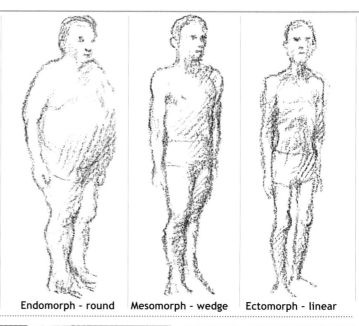

Endomorph – round Mesomorph – wedge Ectomorph – linear

Male and female
These front-and-back views show the basic proportional differences between women and men. Note particularly the heavier build of the male above the waist and that of the female below, the differences in limb and muscle proportions, the apparent length of the necks, and the carrying angle of the forearms.

There are, on average, between seven and eight head lengths to the adult body, no matter what the gender (*see right and pages 18-19*).

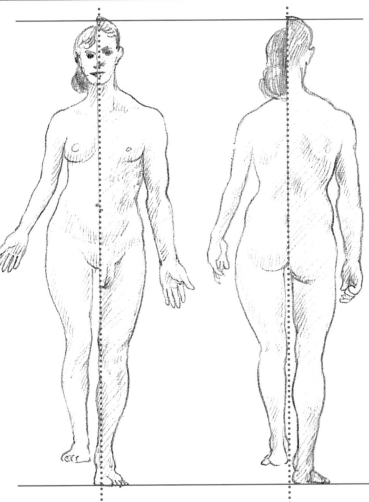

Stature
On average, the female figure is approximately 10cm (4in) shorter than the male. The shoulders and waist are usually narrower than the male's. The hips are proportionally broader and, in profile, the female buttocks protrude more than the male's.

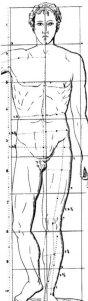

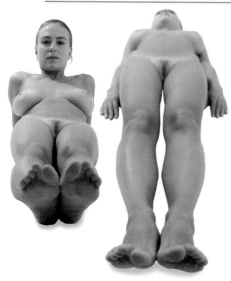

When an object lies at an angle to the picture plane the subject appears compressed, or foreshortened, as it recedes. The technique of foreshortening helps give pictorial reality, an impression of recession or projection, allowing the mind and eye of the viewer to automatically reconstruct the object in the correct proportions.

Principle
The term "foreshortening" is applied to a single object, figure, or part of an object or figure, whereas the term "perspective" refers to an entire scene.

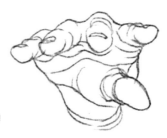

Hand seen from the front

Euthymides
The Warrior's Leavetaking
*c.*500BC
After a vase of the "red-figure" style
Munich Antiquarium

The discovery of foreshortening
A little before 500BC artists no longer drew everything in a flat and stylized form. For the first time in history a foot was drawn as seen from the front. On this vase *(left)* the figures and the right foot, too, were still drawn in the "old" way, but the left foot is foreshortened. Nothing like this had ever been seen before.

Renaissance artists sought greater pictorial reality. Among those who showed a passion for optical trickery, were Mantegna *(right)*, who portrayed Christ dramatically in a steeply foreshortened view, resulting in striking distortions of the body. Uccello *(below, right)* is celebrated as the master of foreshortening and is sometimes wrongly credited with its invention. He is well known for his painting of the Battle of San Romano.

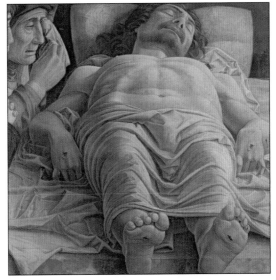

Andrea Mantegna (1431-1506) **The Dead Christ** Late 15th century Brera Gallery, Milan

Paolo Uccello (1397-1475) **The Rout of San Romano** *(detail)* c.1450 National Gallery, London

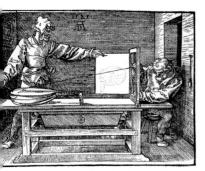

A painter studies the laws of foreshortening by means of threads and a frame. From Dürer's textbook on perspective and proportion.

Albrecht Dürer (1471-1528) **The laws of foreshortening** Woodcut book illustration. Nuremberg, 1525 edition

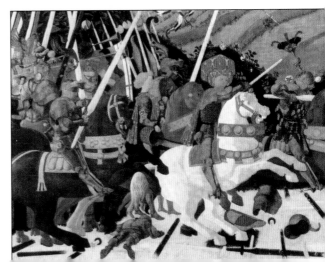

Artists use the device of foreshortening to create the illusion of depth and distance. This effect relies on looking hard and adjusting the natural proportions of the figure. When drawing hands, utilize surface detail, such as skin creases, to convey a similar illusion.

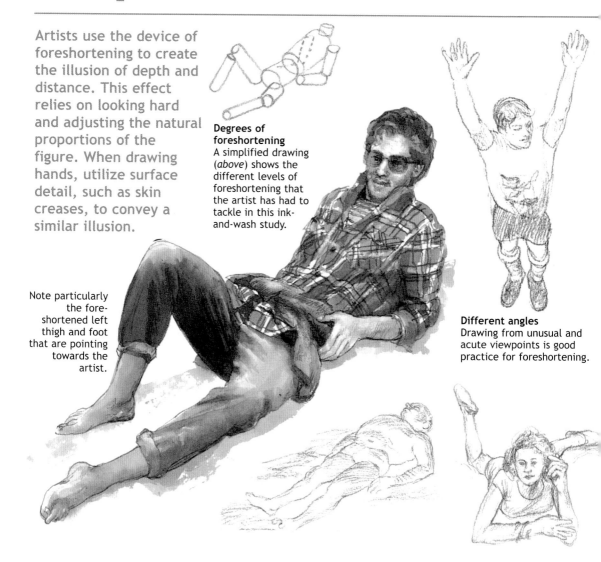

Degrees of foreshortening
A simplified drawing (*above*) shows the different levels of foreshortening that the artist has had to tackle in this ink-and-wash study.

Note particularly the fore-shortened left thigh and foot that are pointing towards the artist.

Different angles
Drawing from unusual and acute viewpoints is good practice for foreshortening.

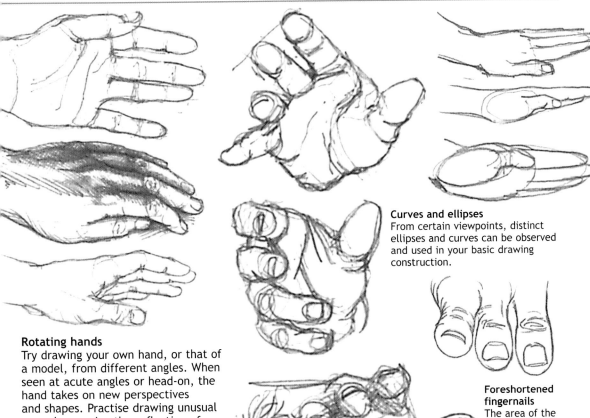

Curves and ellipses
From certain viewpoints, distinct ellipses and curves can be observed and used in your basic drawing construction.

Rotating hands
Try drawing your own hand, or that of a model, from different angles. When seen at acute angles or head-on, the hand takes on new perspectives and shapes. Practise drawing unusual poses by copying the reflection of your own hand in a mirror. Here, the artist has decided to experiment with examples of extreme foreshortening, using a fast, fluid style.

Foreshortened fingernails
The area of the nail appears to diminish as the hand turns towards you.

Seen diagrammatically, the body is a symmetrical structure, with pairs of arms, legs, feet, hands, eyes, and ears appearing the same on both sides. In reality, the artist has to deal with posture, pose and perspective.

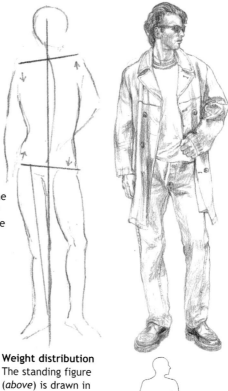

Asymmetry
The weight of the body is normally taken by one side or the other.

Weight distribution
The standing figure (*above*) is drawn in graphite pencil and shows that the weight of the body is being taken by the right-hand side.

Diagram of the body as a symmetrical structure

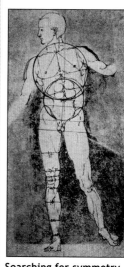

Searching for symmetry
Albrecht Dürer studied mathematics and geometry in the 15th century, and was a master of the woodcut and copper engraving. He was concerned with the aesthetics of balance and symmetry and wrote, printed and published his own books on perspective and the proportion of the human form.

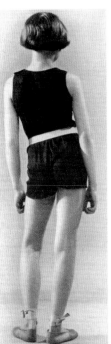
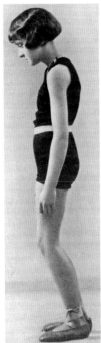
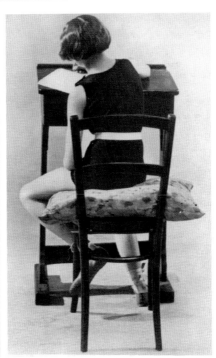

Posture
These examples (*left*), from a medical guide published in the 1930s, clearly demonstrate asymmetrical weight distribution. Be aware of this subtle emphasis when drawing.

Raphael's *Leda*, a classic example of asymmetrical weight distribution

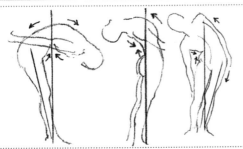

Balance
These sketches (*left*) demonstrate how we keep our balance by constantly making adjustments between the upper body and hips.

In the absence of live models, scale model figures can be invaluable drawing aids - particularly for movement, drapery, and positional studies.

Adult and juvenile hand manikins

Figure reference
Not all of the figures here are designed specifically as drawing resources for artists. However, many provide invaluable reference to the shape and structure of the human body. Hand manikins are also available.

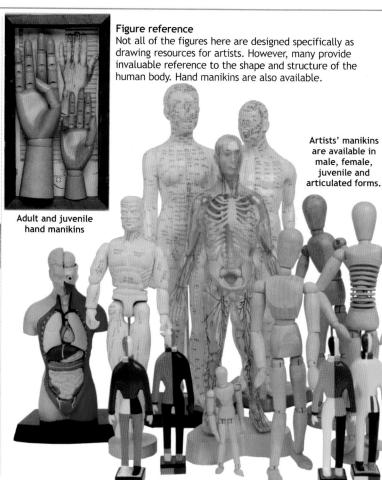

Artists' manikins are available in male, female, juvenile and articulated forms.

Artists' manikins
Manikins are available in a variety of sizes from 13cm (5in) to 170cm (life size, 67in) and are made of hardwood, either unfinished or varnished and polished. These are precision-made models and all limbs are flexible, with high mobility for a variety of poses to draw.

A selection of models of the human form

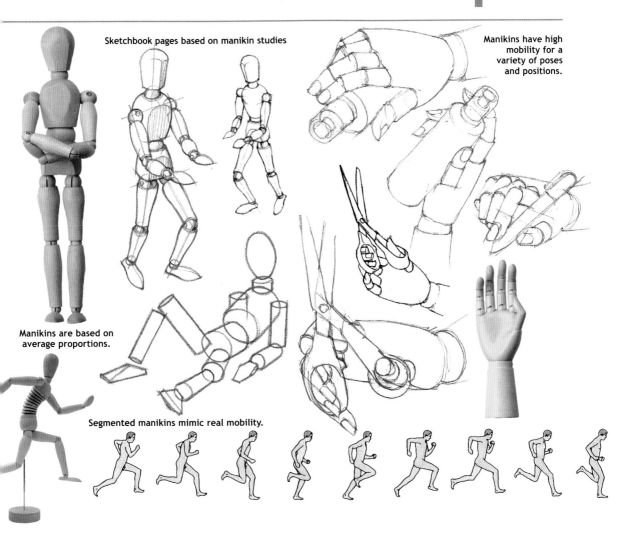

Sketchbook pages based on manikin studies

Manikins have high mobility for a variety of poses and positions.

Manikins are based on average proportions.

Segmented manikins mimic real mobility.

The term "manikin" is used to describe any three-dimensional model of a human form used for drawing reference.

Manikin or lay figure

A manikin, also spelt "mannikin", is also sometimes known as a "lay figure". The original meaning was "little man", "dwarf" or "child". The term now defines a jointed anatomical model of the body or parts of the body for use in art instruction.

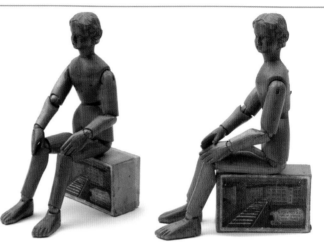

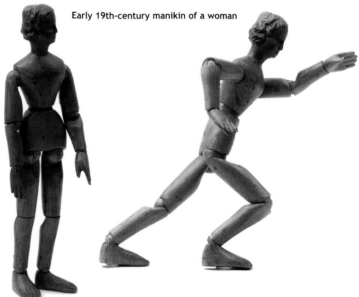

Early 19th-century manikin of a woman

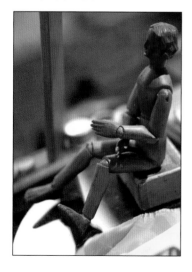

To understand fully how the skeleton and muscles worked, artists once had to resort to dissection. Nowadays many types of models, facsimiles and printed references exist for study.

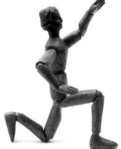

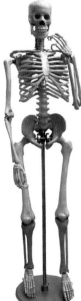

Skeleton
Full-size human skeleton models are available for drawing and anatomical study. The example shown (*left*) is full scale,170cm (67in) high, in wood. Skeletons are also available in smaller sizes and are made variously of wood, plastic or resin. Skeleton details, such as hands, feet and vertebrae, are also available to the artist.

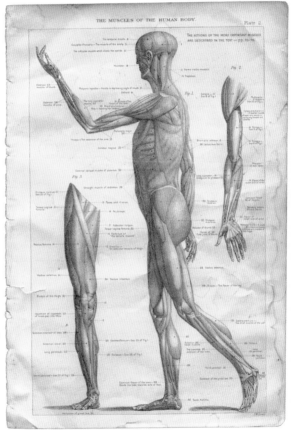

THE MUSCLES OF THE HUMAN BODY.

Ecorché
This term describes a drawing of a skinless human or animal figure, used in the anatomical study of musculature. Perhaps the most gruesome product of anatomical research, the "flay" was a cast taken from a corpse whose skin had been removed in order to show the underlying muscular formation.

34 Drawing from casts

Drawing from casts of classical sculptures or fragments, and capturing them accurately with every precise nuance of shading was once a required part of the curriculum. Today very few art schools include drawing from casts in their study programmes.

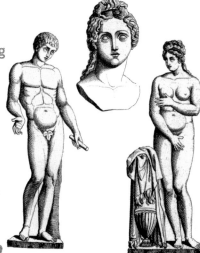

Drawing from the antique
Although the term "drawing from the antique" denotes the copying of classical Greek and Roman sculpture, more recent works were sometimes used, notably the sculpture of Michelangelo, Donatello, Bernini and Rodin.

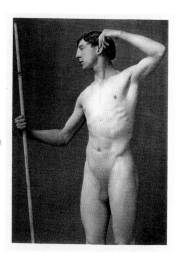

Plaster casts
The casts are white plaster copies of original works, either in the round or in relief.

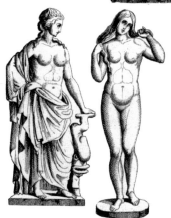

Graduating to life drawing
Drawing from cast was part of a traditional academic art course, the satisfactory completion of which was requisite for entry into a class in life drawing.

The drawing, painting or sculpting of the human form from a living model was once a mandatory part of an artist's training. Today life drawing is an optional course of study at many art schools.

Working with humans

Think about the kind of pose you would like before the model arrives. Ask your model to adopt a seated, reclining or conventional standing pose for long figure-study sessions.

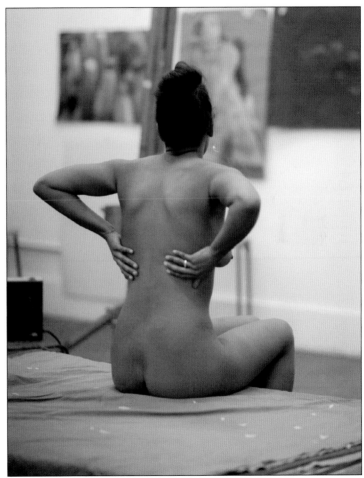

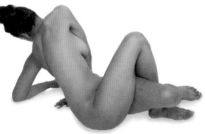

Try short ten-minute sessions for more unconventional, contorted or twisted poses, or for dramatic action and movement studies.

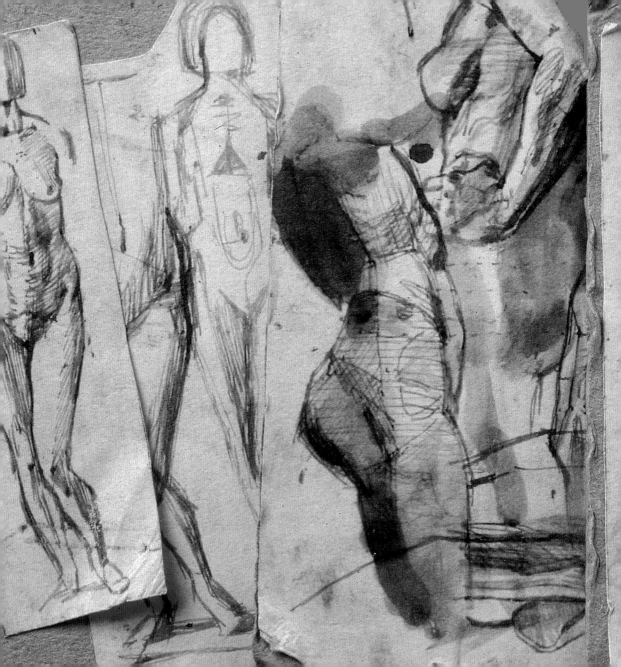

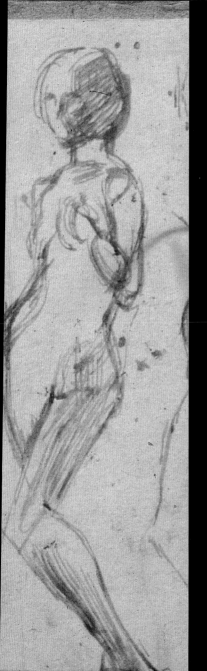

starting
points

Keeping a sketchbook will provide you with a large visual library of images and act as a pictorial diary. Making sketches in the studio and in everyday situations will improve your visual memory and sharpen your powers of observation.

Museum notes in sketchbook

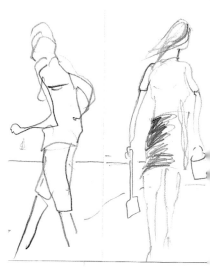

The importance of the sketchbook

Some artists build a library of sketchbooks with notes and part drawings, as well as photographs and reference pictures cut from newspapers and magazines. These can be used as supplementary information to add to unfinished drawings made on the spot.

Drawing speed

Because you do not have the luxury of spending much time on a single figure or pose, your drawing speed should improve, and the more you sketch, the better your eye-to-hand coordination will become.

Colour notes in sketchbook

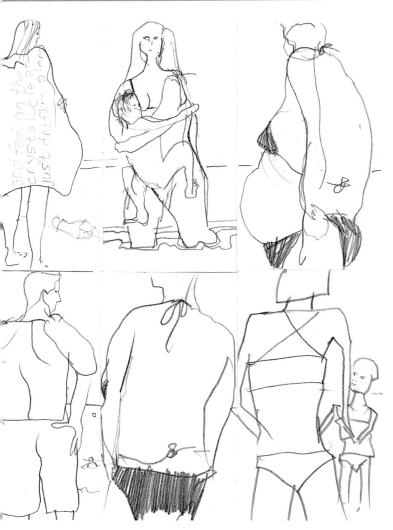

Sketchbook page in oil pastel

Visual note-taking
These sketches form a series of visual notes for working out a finished drawing. The bathers were drawn enjoying themselves on the beach, and they provide a wide variety of body types and poses; oil pastel (*above*) and graphite pencil (*left*) were used. Because many subjects will be on the move, you have to work quickly and cultivate your memory to get what you have seen down on paper.

One-minute drawings made using graphite pencils; sketching is a way of visual note-taking.

40 Clothing and props

The majority of figures you draw outside the confines of the life class will be clothed or, at least, draped, and, in a normal situation, will be engaged in some kind of activity that will include props, such as a shovel for digging the road, or a shopping bag or basket.

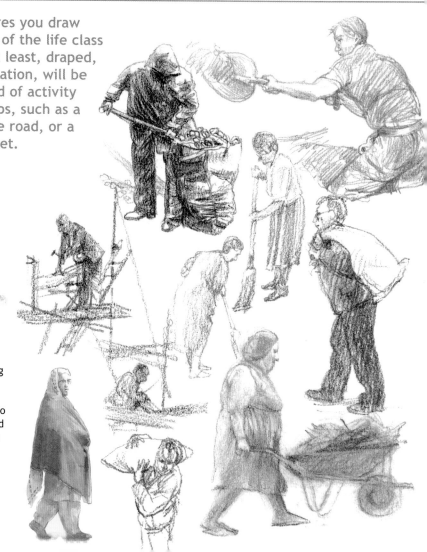

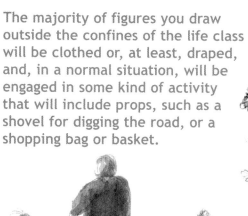

Variety and contrast
When you are out sketching, people will inevitably be doing something as they go about their everyday lives. This provides a great opportunity to include all sorts of objects and costumes in your drawings, as shown in this lively selection from a sketchbook.

"Costume life" is the term used when garments and drapery are introduced into the life class. In addition to mastering the portrayal of flesh, the student has the additional challenge of drawing cloth covering the human form.

Clothing and props in the life room
You can decide collectively beforehand whether you wish to use drapery, props, or clothing in the session, and how it is to be provided; if you ask, the model may be able to bring items.

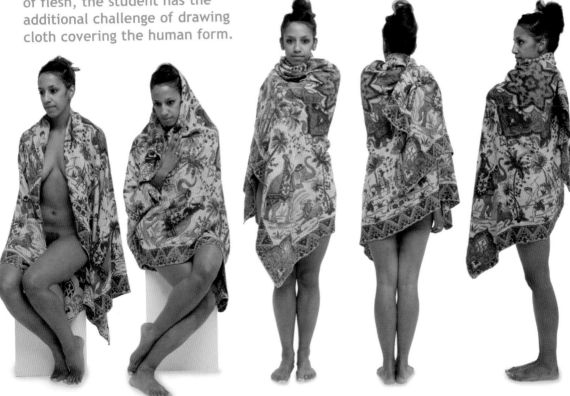

Friends and family provide readily available models and are often happy, indeed flattered, to model for the artist. Drawing friends and family is best achieved in a relaxing place - usually at home. Placing models in their surroundings adds an extra dimension to drawings, as people unused to sitting for an artist may be fidgety or nervous, and a prop may often relax them.

Amateur models
Let the models choose the setting, and the likelihood of a successful pose will increase.

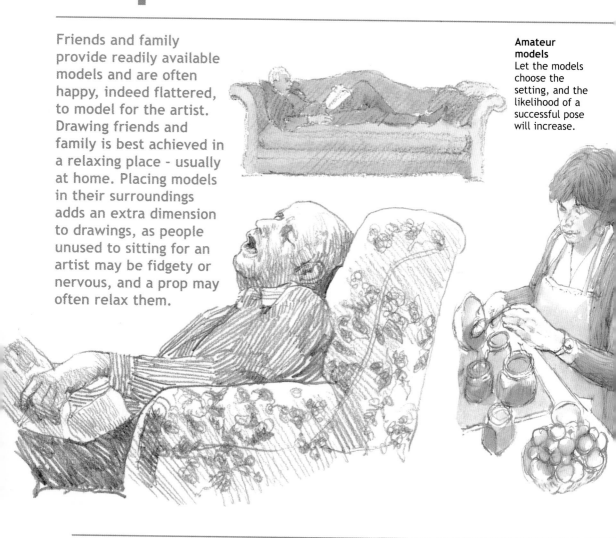

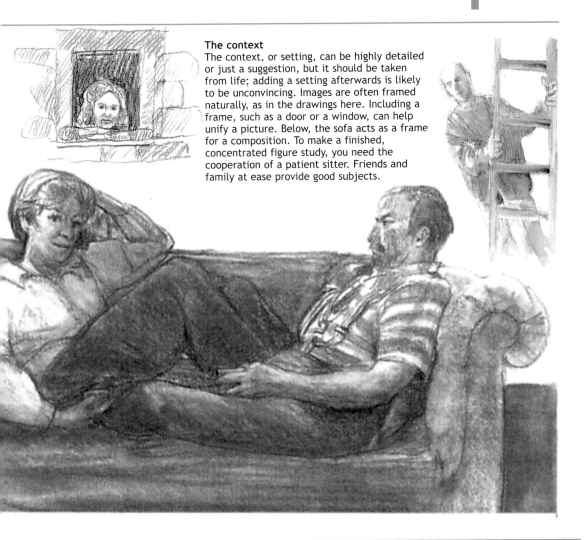

The context
The context, or setting, can be highly detailed or just a suggestion, but it should be taken from life; adding a setting afterwards is likely to be unconvincing. Images are often framed naturally, as in the drawings here. Including a frame, such as a door or a window, can help unify a picture. Below, the sofa acts as a frame for a composition. To make a finished, concentrated figure study, you need the cooperation of a patient sitter. Friends and family at ease provide good subjects.

44 | Young models

There is as much variety among babies and small children as among adults; they are of all shapes and sizes, and each is an individual. Do not fall into obvious preconceptions about young facial features or proportions, but observe closely and make lots of sketches.

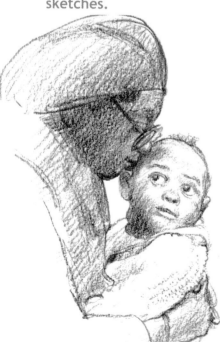

Proportional relationships

The relationship of parent to child is an important element in these drawings (*left and above*). To focus attention on the baby, the mother's face is drawn in full, heavy shadow. The shape of a baby's skull is very different from that of an adult, especially before the fontanelle has fully closed. Facial proportions are also different, and will change as the child grows older.

Hands

Although very young hands vary in shape from one infant to another, the differences are hardly apparent, due to their protective layer of fat. In general, babies and young children have tiny dimples instead of knuckles, and sometimes deep creases near the barely-defined wrist.

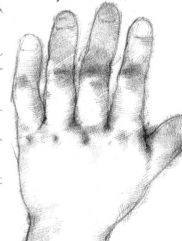

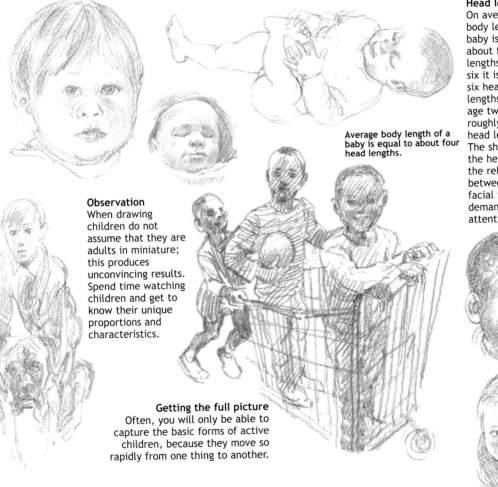

Head lengths
On average, the body length of a baby is equal to about four head lengths, at age six it is about six head lengths, and at age twelve it is roughly seven head lengths. The shape of the head and the relationship between the facial features demand special attention.

Average body length of a baby is equal to about four head lengths.

Observation
When drawing children do not assume that they are adults in miniature; this produces unconvincing results. Spend time watching children and get to know their unique proportions and characteristics.

Getting the full picture
Often, you will only be able to capture the basic forms of active children, because they move so rapidly from one thing to another.

46 Models in groups

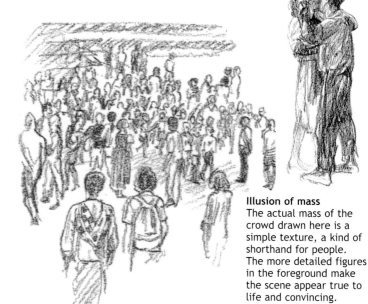

Drawing more than one figure allows you to express relationships and emotions, such as friendship, love, indifference, a common purpose, or a mass focus of attention, that are not possible with a single figure.

Illusion of mass
The actual mass of the crowd drawn here is a simple texture, a kind of shorthand for people. The more detailed figures in the foreground make the scene appear true to life and convincing.

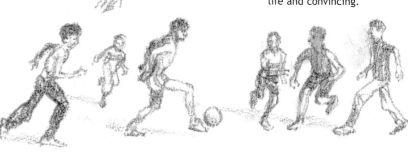

Building up a crowd

This group of people was not drawn as a unit, but was built up with individual figures drawn from the same viewpoint at a market. The artist used a broad lithographic pencil: this must be used confidently, because it is hard to erase, but it is a versatile medium and does not smear. It is also possible to assemble your own crowd scene from individual studies made at different times in your sketchbook.

Choice of medium

Crowds and groups can be effectively portrayed in detail by using a linear medium, such as graphite or charcoal pencil, or pen and ink, or as a mass of tone and colour, using charcoal, watercolor washes, or pastels, for example. Combine the two types of medium to produce rich, colourful studies.

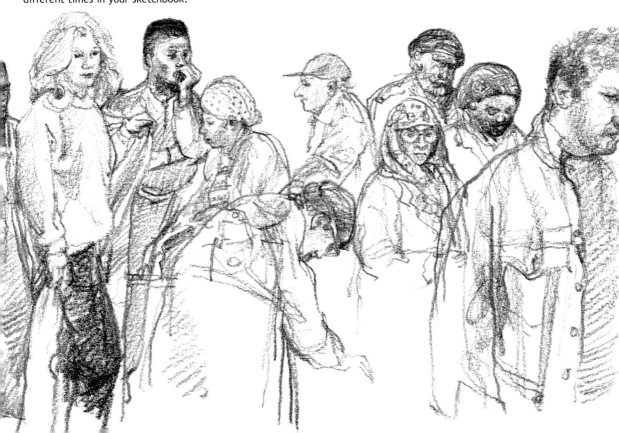

48 The naked model

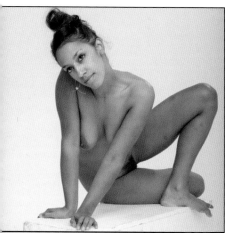

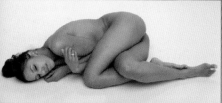

The effects of poses
These two images show how different poses by the same model can emphasize contrasting qualities of the figure. Sitting up, the body is compact and folded in on itself, almost like a geometrical triangle; but when it is lying down, notice how lean and taut the model's body is, more like a landscape.

Since the Renaissance, drawing and painting the naked human form have been the backbone of serious art study. Professional models can be contacted through a local art group, who could collectively hire the model. Many adult education centres run life-drawing classes.

Working with your model
You will probably get better results if the model can play a creative part in the session; he or she should be consulted about poses, or you can allow him or her to choose those that are the most comfortable for long periods. (Most of the life-drawing poses in this book were chosen by the models, in consultation with the artist or tutor.) About an hour for each pose is standard, but be advised by the model if you are not sure. Regular breaks are essential, and the model should be allowed to relax and keep warm between poses. Do not forget to provide changing facilities.

Wide-ranging possibilities
A life-drawing session can expand your artistic boundaries. Your viewpoint, your chosen medium, the model's pose, the lighting and background – all these will have a material effect on how your drawings will turn out.

Location and environment
Try to arrange the session in a reasonably large, warm space, so that the artists are able to set up and draw from whatever angle they choose; it may be difficult for artists to produce satisfactory work when they have not chosen the viewpoint or are unhappy with it for some reason.

Viewpoint

Choosing a viewpoint starts from the moment you take your stance or sit down. It has a crucial influence on your end results, as it will dictate exactly how much, from what angle, and which scale you see. Do not be afraid to move around the life room looking for the viewpoint that suits you most and allows you to settle in for a long session. If need be, make preliminary sketches; if you are still not happy, try another viewpoint.

Framing and composition

Consider how the model will best be placed on your paper, and where the edge will cut off the image. In general, it is sensible not to have heads or feet disappearing out of the bottom or top of the work, but artists sometimes do this for an effect.

Background and lighting

When drawing from life, it is worth paying attention to the background, whether or not you include it in your drawing. The light reflected from dark and pale walls is different, and this will affect the way you see line and form. Natural light is best, but this is not always available; artificial light can be harsh and fluorescent lighting can diffuse shadows.

Five-minute studies

Quick sketches from life can capture the mood and atmosphere of a pose. You do not always have to spend the entire time drawing the whole figure in a life-drawing session – concentrate on whatever limb or detail you feel is important or needs more practice.

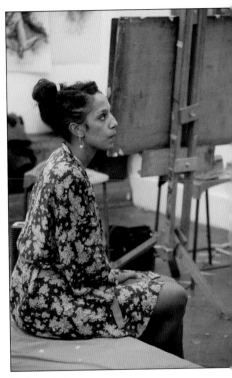

In the art class
Drawing in groups is a good way to meet other artists, to compare, and to discuss work. Regular breaks are essential, and the model should be allowed to relax and keep warm between poses.

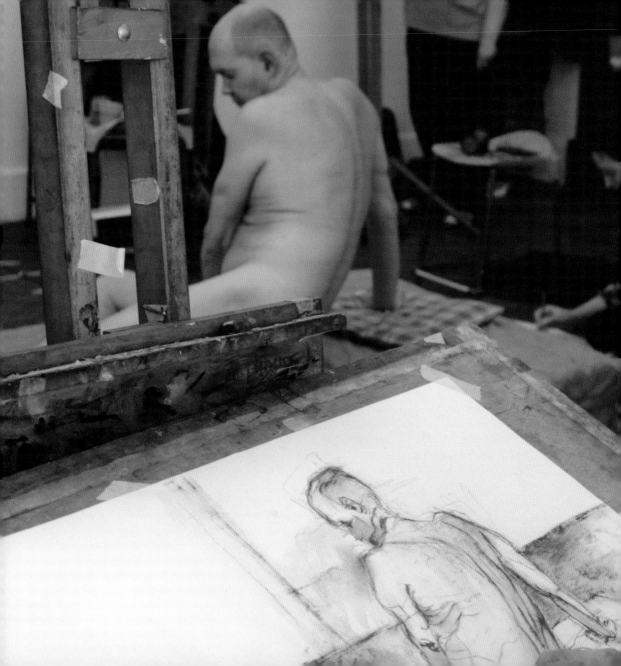

in the life class

52 | A day in the life class

This life class is of two hours' duration and is broken up into two sessions. The first session consists of short, spontaneous poses of a couple of minutes' duration. After a break the tutor sets a more concentrated pose of an hour or so, with short model breaks about every fifteen minutes; break times depend on the stamina of the individual model. Structuring the class in this way provides variety and stimulation for both the students and the life-drawing model.

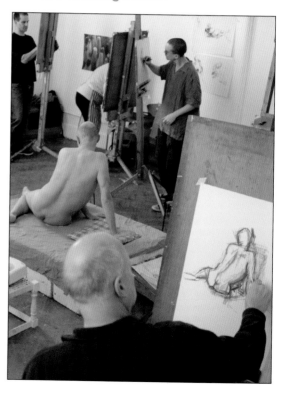

Life models

Like people in every profession, life models are a wide range of shapes, sizes and complexions. Some are known for their ability to hold long and complicated poses, while others are regarded for their stature and features. The aim of a good life class is to enthuse the artist with a variety of models and poses.

Equal opportunities

Historically the female figure is the classic choice for portraying the naked human form. There are many theories and arguments as to why this should be the case. However, today all educational establishments provide opportunities to draw from either a male or female model.

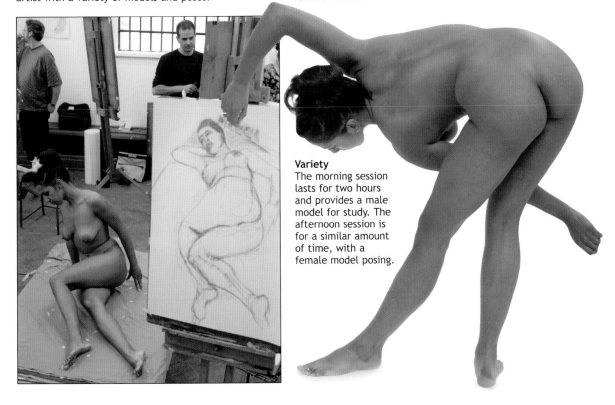

Variety

The morning session lasts for two hours and provides a male model for study. The afternoon session is for a similar amount of time, with a female model posing.

54 | Observation and inspiration

As an artist who runs open life-drawing classes, Stephen Palmer describes his approach to teaching as that of a facilitator. By this he means that he presents the opportunity to study the human form in a studio situation with a professional model. There is no formal teaching structure as such; the objective of the class is to inspire the students to observe and interpret the human form and to exercise their creative and technical skills.

The students
come from a wide range of art experience. Some are art students, others are professional artists or those involved in creative professions who want to keep their "hand and eye in". Others may be returning to art after years of absence.

The tutor
runs the class, sets the poses, organizes the models and materials, and advises the students as their work progresses.

The models
are professional life models who are able to sustain long, and often demanding, poses.

Tim Ralston (graphite)

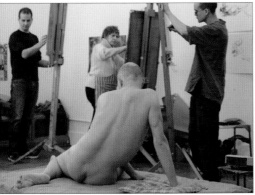

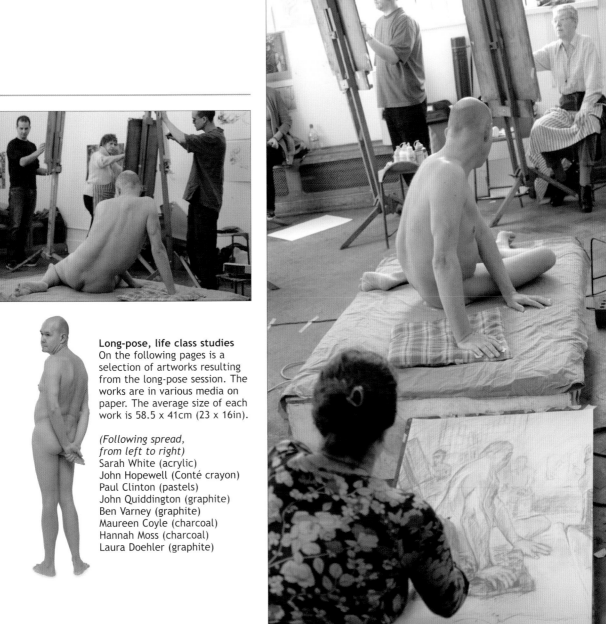

Long-pose, life class studies
On the following pages is a selection of artworks resulting from the long-pose session. The works are in various media on paper. The average size of each work is 58.5 x 41cm (23 x 16in).

*(Following spread,
from left to right)*
Sarah White (acrylic)
John Hopewell (Conté crayon)
Paul Clinton (pastels)
John Quiddington (graphite)
Ben Varney (graphite)
Maureen Coyle (charcoal)
Hannah Moss (charcoal)
Laura Doehler (graphite)

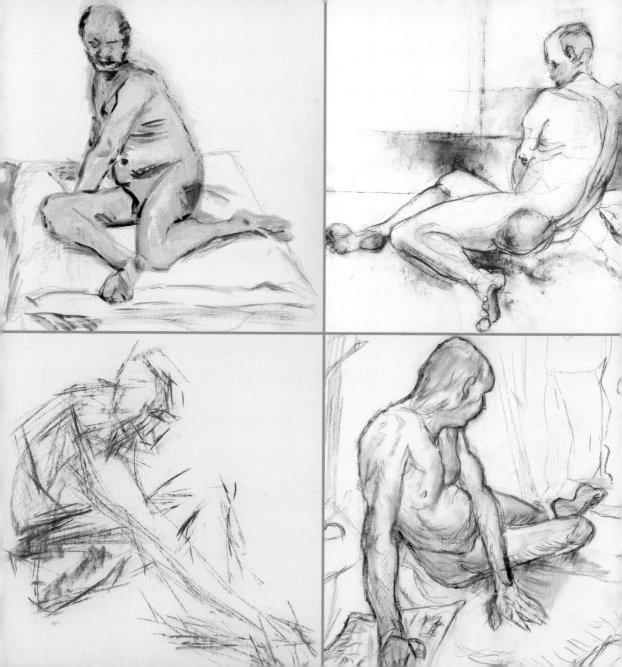

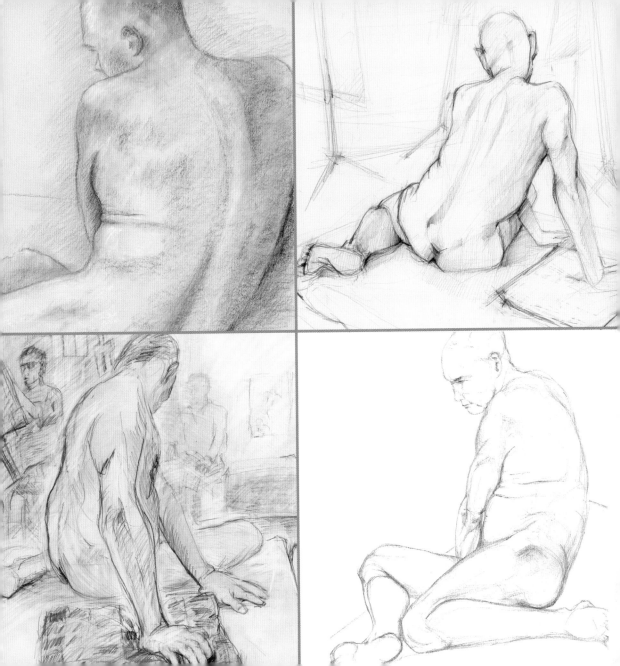

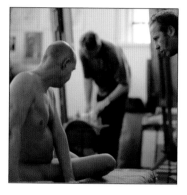

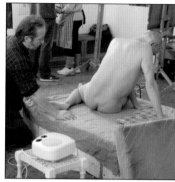

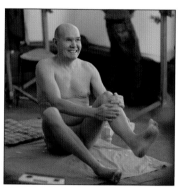

Life class, long pose
(Above, from left to right) The tutor asks the model to take a break; the pose is marked on the dais with tape; now the model enjoys a well-earned stretch. *(Opposite)* Detail of tape marking the position of the pose.

An experienced tutor together with a professional model will create an atmosphere in the life class that is relaxed and secure. To maintain poses for long periods of time the model has to feel comfortable, and it is important that the climate in the life room is pleasant. The students and their model enjoy a special working relationship during the session and regular breaks in an atmosphere of concentration are essential for all participants in the life class.

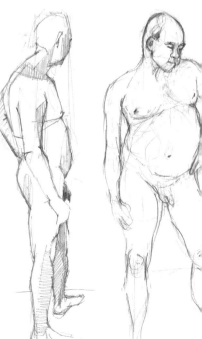

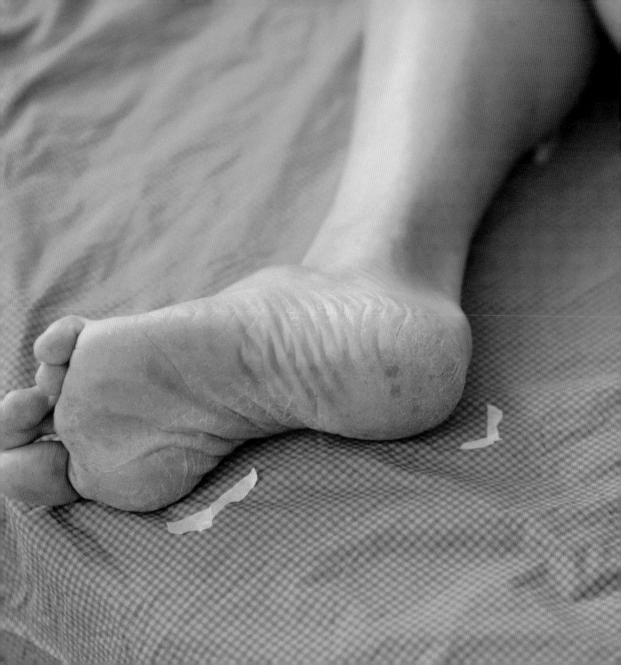

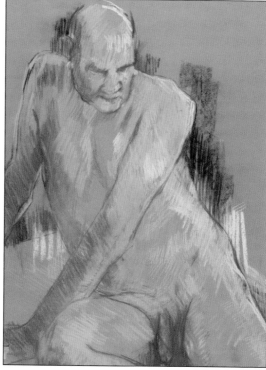

A typical class will see students using a wide range of media.

Life class, long pose
Dora Tuttiet
Pastel
on tinted paper
84 x 51cm
(33 x 20in)

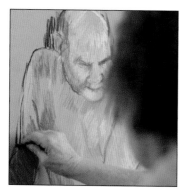

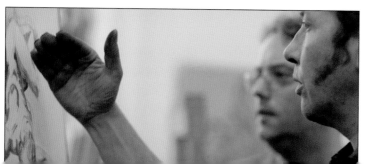

Two pairs of eyes
The tutor advises a student on interpretation and technique.

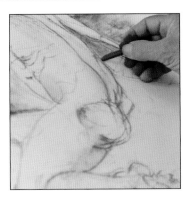
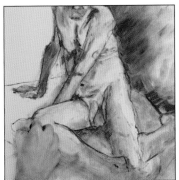

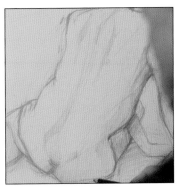

Choice of materials Charcoal is a traditional medium for life drawing (*see page 62*) and this, along with a good quality, off-white cartridge paper, is provided for each session. However, choice of materials is left entirely up to individual preference; there are no rules. A typical class will see a wide variety of media and methods employed, ranging from fine graphite pencil line, through soft chalk pastels, to expressive acrylic brushwork.

62 | The experience of charcoal

Soot and sticks from the fire have been used for drawing since prehistoric times. Pigment from charcoal is also used in paintmaking. Vine black and carbon black, for example, are two well-known artists' colours made with carcoal.

Tone and texture An effective method of achieving variety in tones is by smudging and blending with the fingers. You can then pick out the highlights with a kneaded rubber.

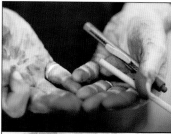

☛ **Life class, long pose** Adam Taylor Charcoal on paper 84 x 51 cm (33 x 20in)

A painterly medium First, the artist rubbed a ground of charcoal over the complete surface of the paper, and then conjured his drawing from this toned background. Shape and light were wrested from the background with a kneaded putty rubber and the figure emerges as a rich variety of marks, ranging from soft and tentative, to bold and fluid.

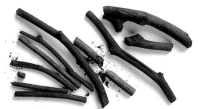

Charcoal encourages the treatment of the subject in broad terms. It is a liberating medium, and an immediate and responsive material, almost like the extension of one's own fingers. It is a forgiving medium, too, as unwanted marks can easily be erased or obliterated. Charcoal is hugely versatile; by twisting and altering the pressure on the stick you can create a wide range of marks. By drawing the side of the charcoal stick lightly over the paper you can also exploit the texture and grain of the paper.

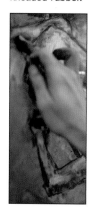

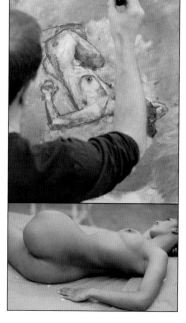

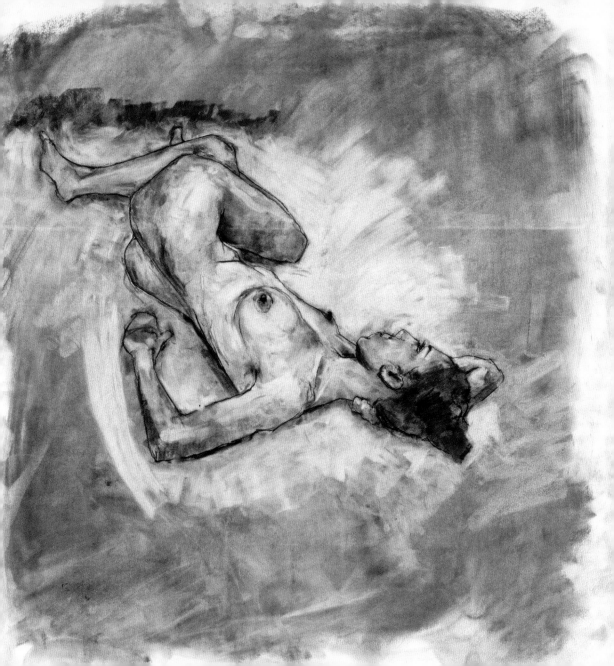

life class
figure
reference

66 Model reference poses

Unlike professional artists, who are able to choose their models for inspiration and purpose (*see page 86*), the student attending a life class does not usually have the luxury of such a choice. The gender and the physique of the model, and the model's posing style, will vary from class to class, and even from session to session, and the class members usually have to accept what is given, though they may have a say when it comes to posing the model. Many models pose for the same life class on a regular basis and this has the advantage of allowing the student to become familiar with the model's form over a period of time.

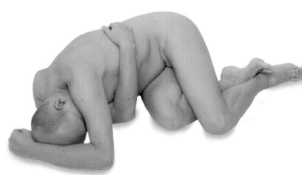

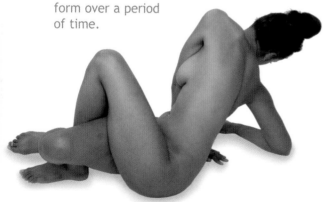

In the life class under discussion here the class lasted for a whole day and was split into two halves, a morning session and an afternoon session. The class was fortunate enough to be presented with both a male and female model of contrasting stature and complexion, which provided the students with both variety and inspiration, as well as presenting a number of technical challenges in drawing the human form.

The life-class models kindly agreed to extend their time to provide the reader with further poses and photographic references, which appear on the following pages.

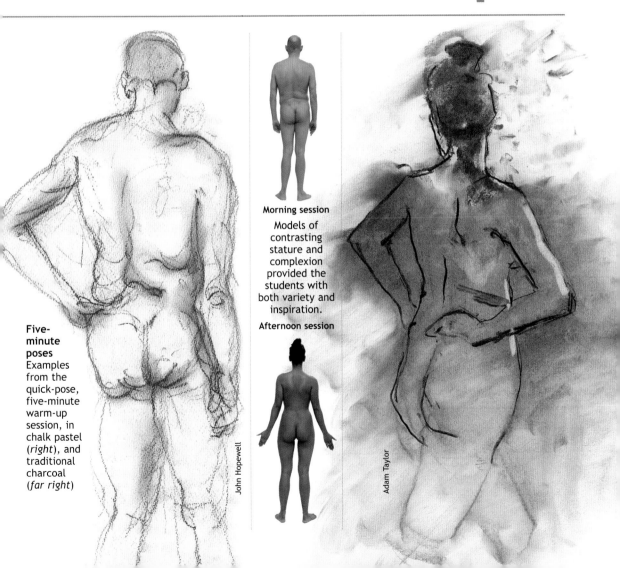

Five-minute poses
Examples from the quick-pose, five-minute warm-up session, in chalk pastel (*right*), and traditional charcoal (*far right*)

John Hopewell

Morning session
Models of contrasting stature and complexion provided the students with both variety and inspiration.

Afternoon session

Adam Taylor

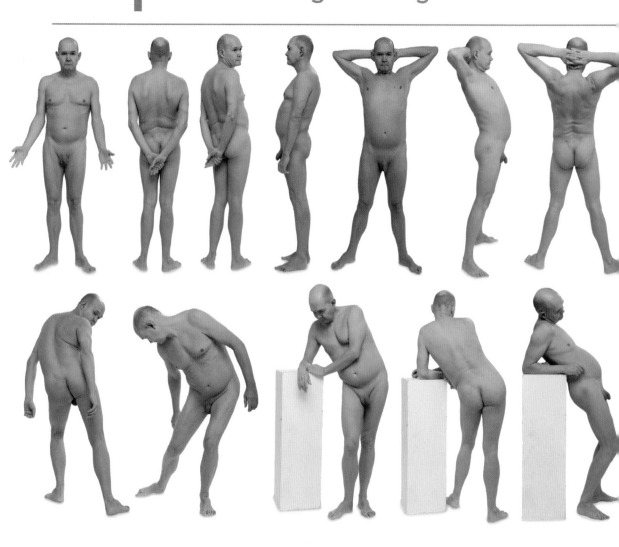

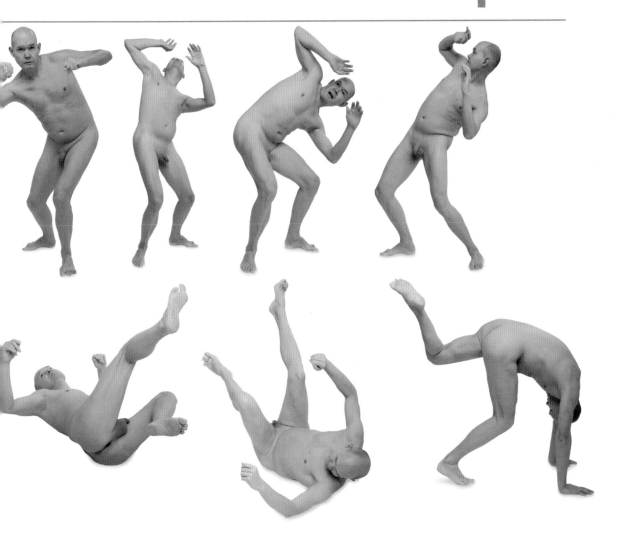

Figure reference: life class
Male: stepping/on all fours

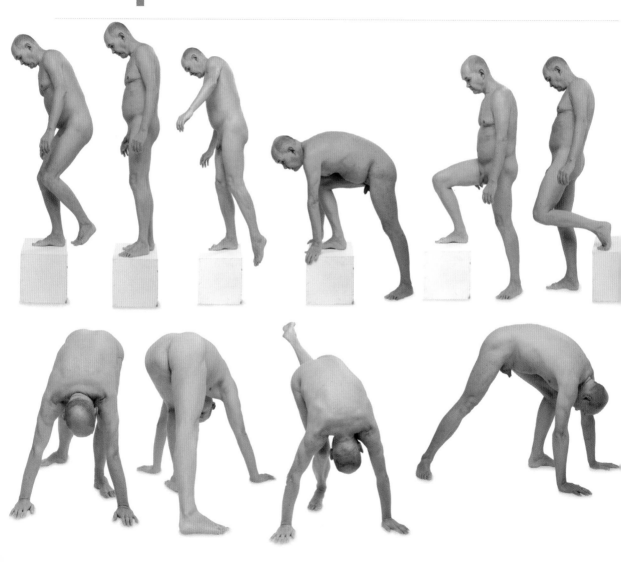

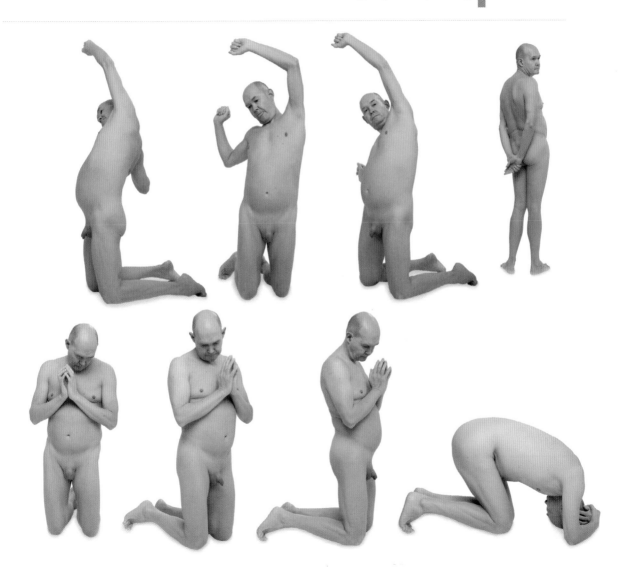

72 Male: pulling/throwing

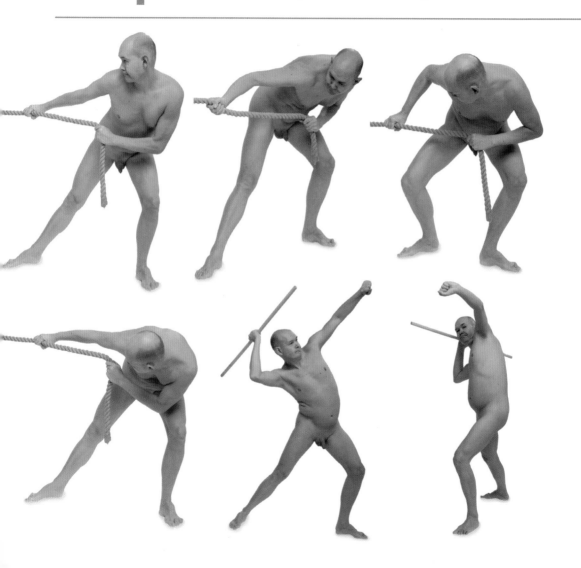

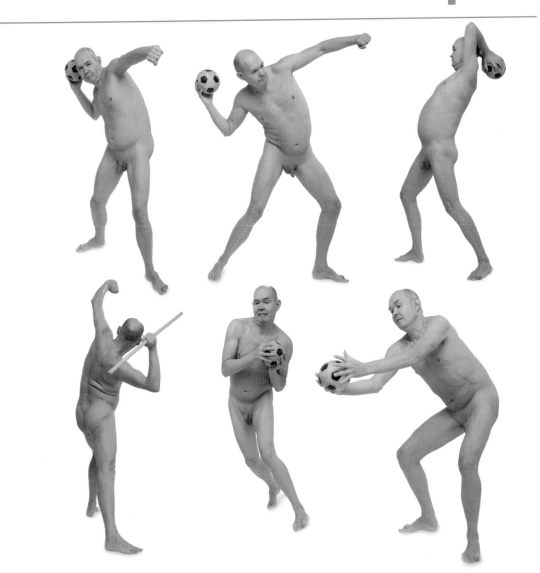

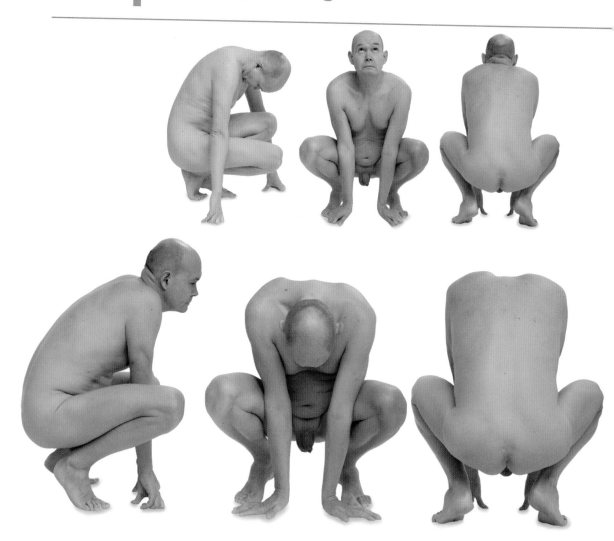

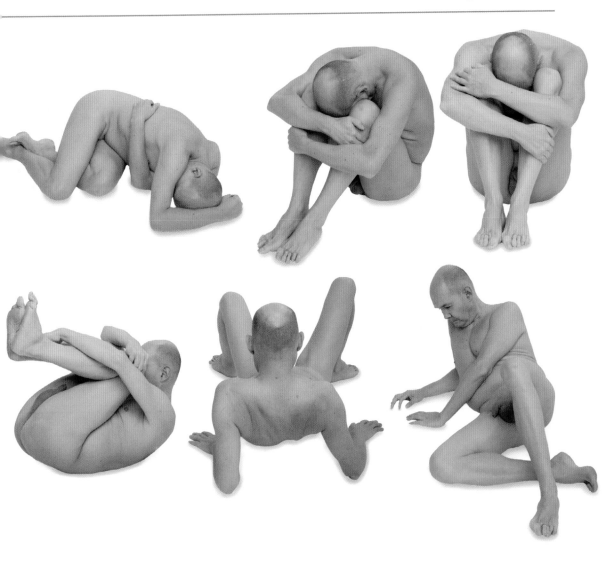

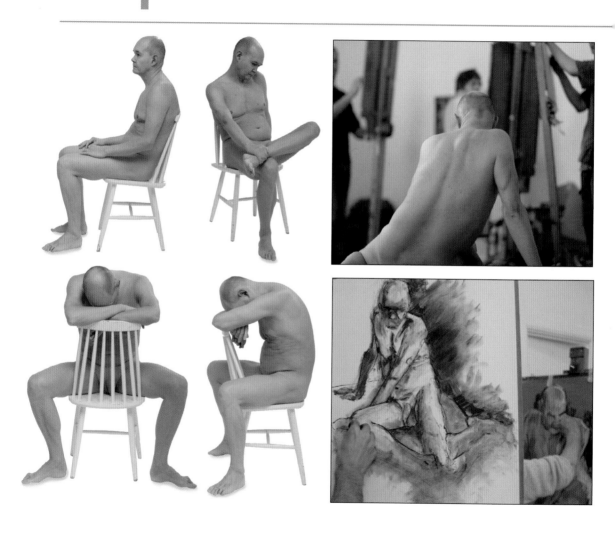

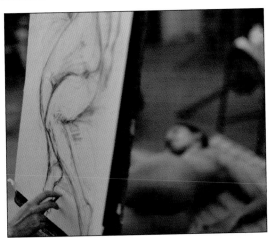

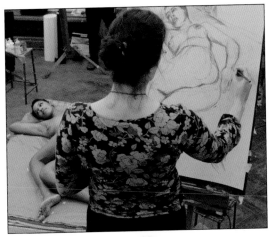

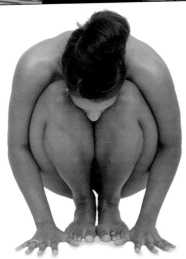

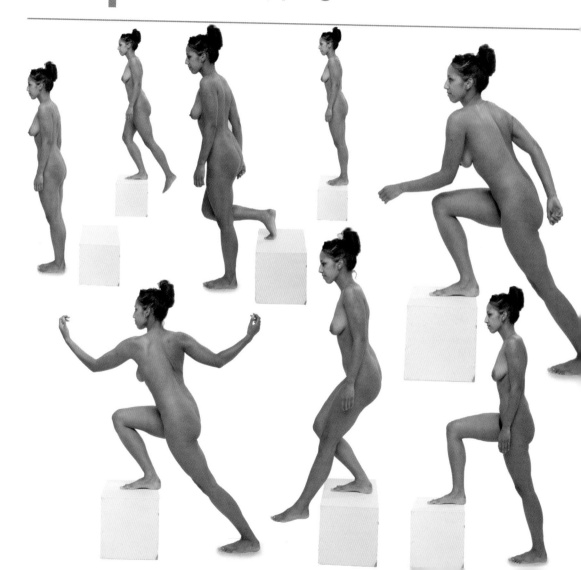

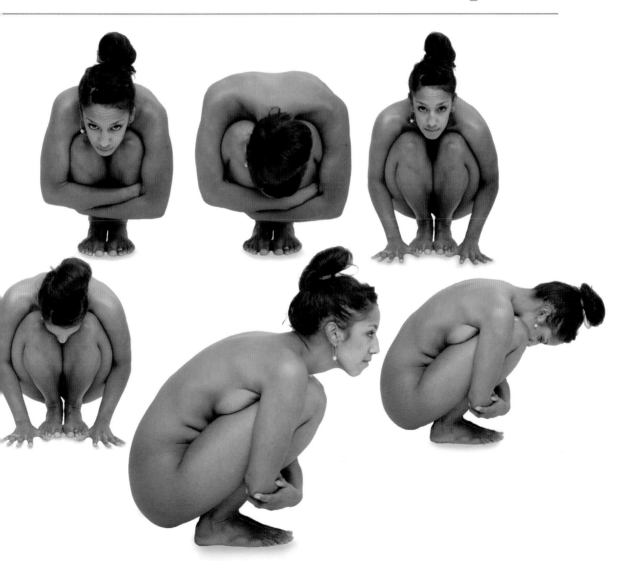

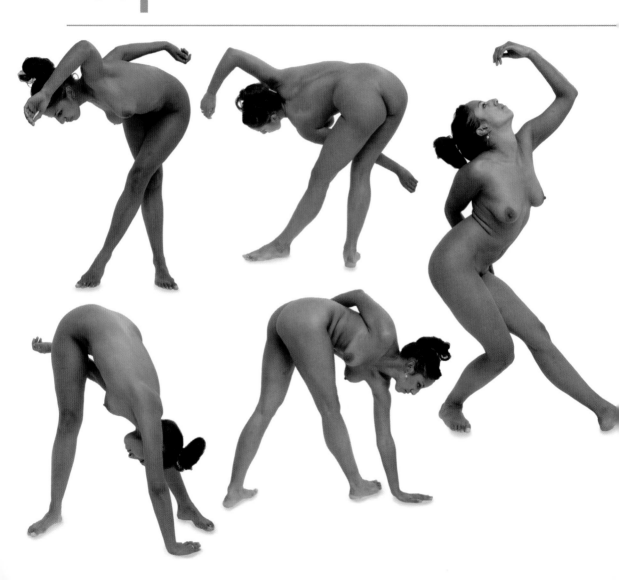

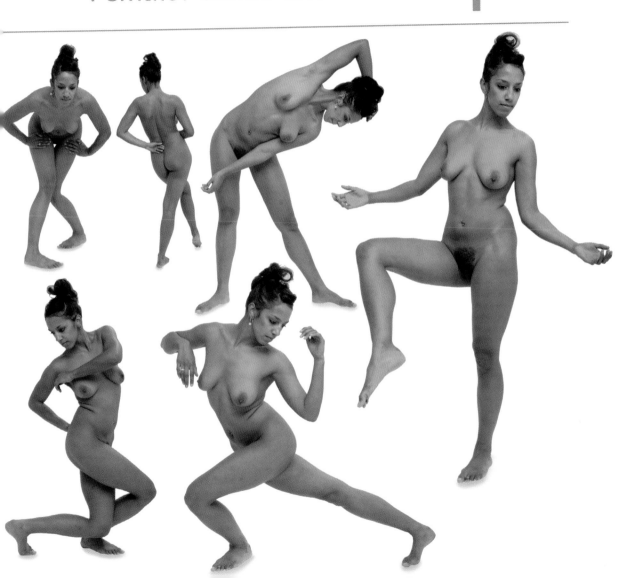

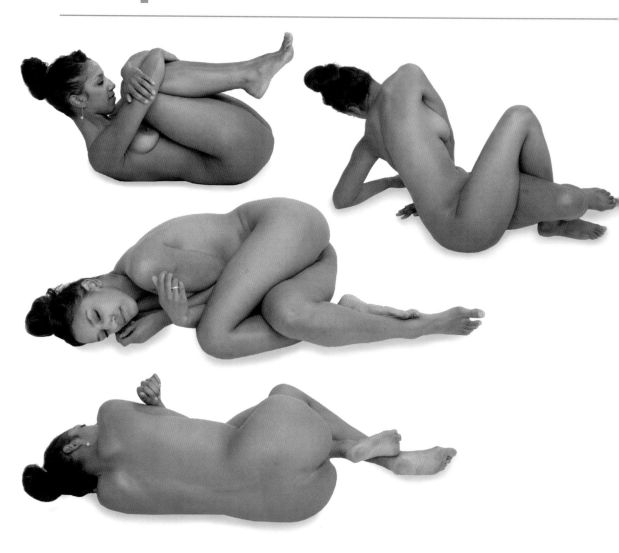

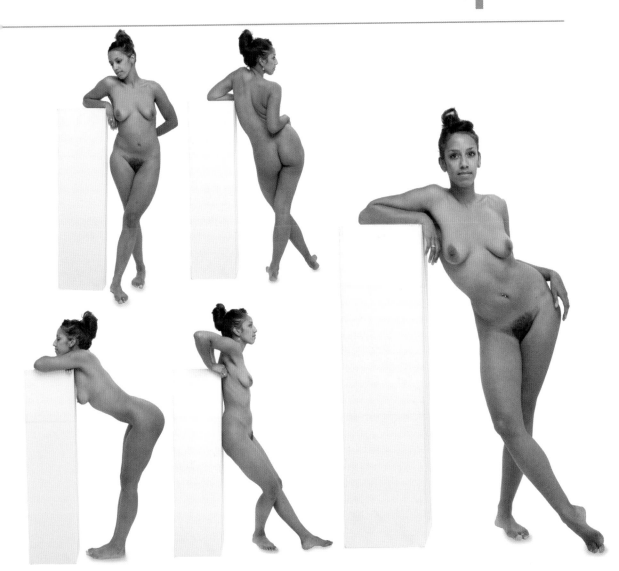

in the
studio

There is a time-honoured tradition of drawing the female figure, and this is an important discipline to uphold. It allows the artist to feel engaged in the same aesthetic concerns of image-making as, say, the Ancient Greeks and Romans. Robin Holtom is not particularly interested in originality of subject; it is not the most essential part of his creativity. He claims that many people these days confuse originality with novelty and, in turn, the world of art has often become confused with the world of entertainment.

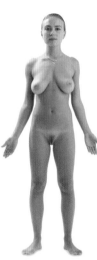

"I feel amazingly close to the classical and Renaissance artists when I am drawing nudes. I experience a kind of comradeship, a hotline to Michelangelo, if you like. When you spend a lot of time working alone, as I do, when someone comes to the studio it is a good occasion. I like the etiquette of working with a model. I like the intensity of observation required and along with this the intimacy, but it is, above all, a working relationship with very clear intentions and boundaries."

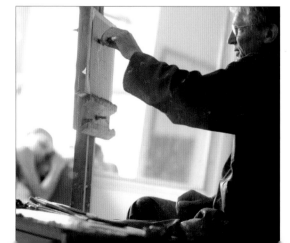

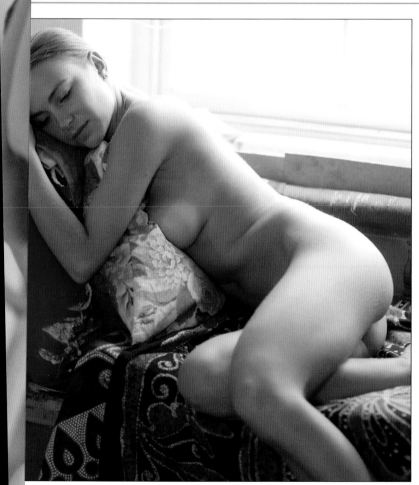

"I prefer working with models who have little or no experience. I like people who I feel are sympathetic and beautiful. I don't mean beautiful in the photographic sense; I am not looking for perfection. I need a model who is interesting and who I like the look of, one with whom I feel a rapport – this is very important. When posing the model the first thing I consider is the rectangle. I ask myself, what do I want to get out of this? I think about the shapes and curves, the angle of a knee, the curve of a hip, for example. I try a few variations of position and viewpoint and ask if this pose is going to be comfortable to hold. I am thinking about the light and the shade – the natural light in this studio is particularly dramatic. Then I decide, should this be a horizontal work, or vertical? It is not always obvious."

Model pose for a thirty-minute colour sketch (*see pages 96-97*)

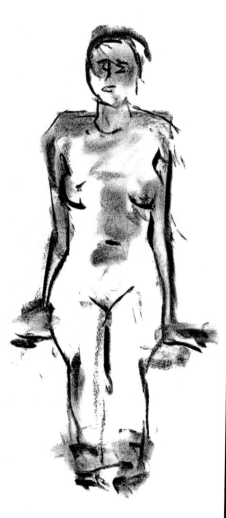

"I often use sketches to kick-off a life painting. In nature lines do not exist because everything is composed of surfaces and volumes. Preliminary drawing is like making a map that helps you to familiarize yourself with the unknown territory that lies ahead."

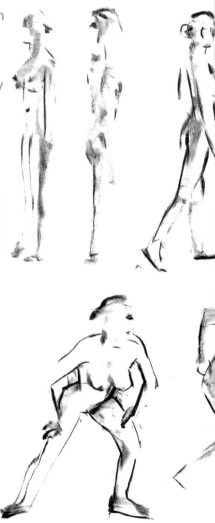

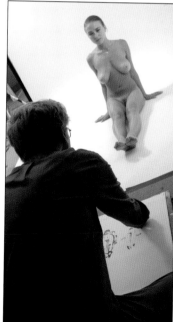

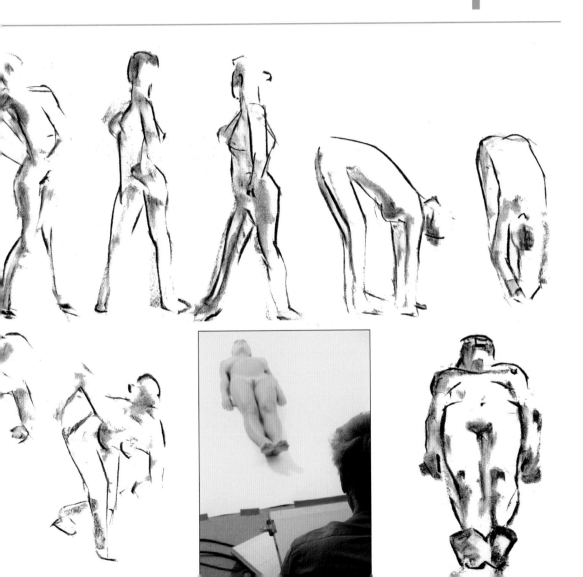

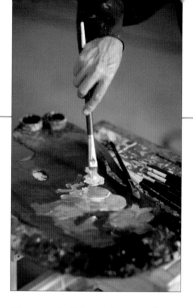

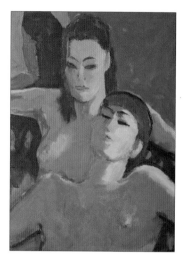

"I like to alternate between drawing and painting. Working in oils changes my routine from working on charcoal drawings and helps me to see the human form afresh. Once I have made a drawing, a map of lines that do not exist in reality, I have some indication of the way forward (*see page 90*). In painting I feel that I am seeing the surfaces of the body and exploring new territory. I can progress to brushes and colour to convey something more real and more solid in an attempt to communicate that direct sensation."

"I use a number of brushes at a time, reserving each for a particular mixed colour, which enables me to work quickly and instinctively."

"I use a bright palette of primary colours, and from these I mix my secondary and tertiary colours. These primaries are arranged around the palette from the yellows to the blues. Within each colour division I have a warm and cool hue of the primary colour. I use titanium white for my tinting colour and I also use a brilliant pink, which is straight from the tube. I use one earth colour on my palette, and this is raw sienna. I create other earth colours, such as burnt umber and sap green, by mixing my primary colours."

"The real test of an oil painting is if at the end of the day it looks better than the palette, the work is going OK."

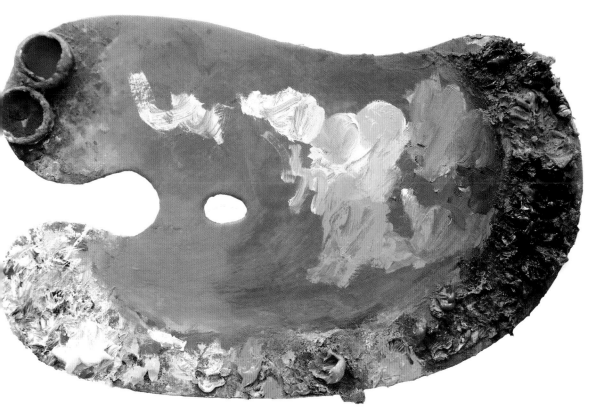

Palette layout anticlockwise

Titanium white
Lemon yellow (cool)
Cadmium yellow (warm)
Orange (warm)

Raw sienna (earth)
Brilliant pink (warm)
Cadmium red (warm)
Rose madder (cool)
Alizarin crimson (cool)

Magenta (warm)
Mauve (warm)
Ultramarine blue (warm)
Cerulean blue (cool)
Turquoise (cool)

"When we are set up and the model is comfortable, I frame up the pose, with my fingers acting as a viewfinder. I then find the middle of the composition and establish the centre of the image on the paper with a little cross. This is my starting point, one to which I can return if I get lost. I then simply draw in the breast, arm, hip, and knee, and establish the composition in charcoal.

I get to work in colour more or less straightaway. I want to get involved with tone as soon as possible. I work with my colours from light to dark on fairly dark pastel paper.

I start the image with the cool and fairly light colours. This has a practical reason, too; they are easier to paint over than the darker, warmer hues. I half close my eyes and lay down the rough scheme of things. This simplifies the subject and helps establish the basic tonal design of the painting.

I work with big brushes as much as possible. This helps me to make simple, bold decisions and keeps the painting alive. I will work on the figure, and then perhaps just indicate the back of the sofa with a blob of orange. I rely on colour and simplicity to create depth and I indicate the window sill and the window frame in warm yellow to create perspective, and suggest the cushion with a spot of green-grey before returning to the figure.

I leave the head late. If you try to make the body fit the head you can run into trouble. When I am confident that it is where it should be and in proportion to the body, and I can make it more definite and warm it up a bit. I am working with sunlight, which changes all the time, and this keeps me on my toes as I try to create a sense of this light coming through the window.

I like to work with a bright palette, with colours that on the face of it may seem difficult to use. At this point I start to build the painting and solid colour forms, and to emphasize the way the light falls on the head and shoulder. I use fairly strong outlines as a form of shorthand to pull the work together and to act as a record for developing the painting later.

We will take a model break now. These breaks are important for the artist, too; they provide time for reflection and enable me to resume work with a fresh eye and an objective view of where I am."

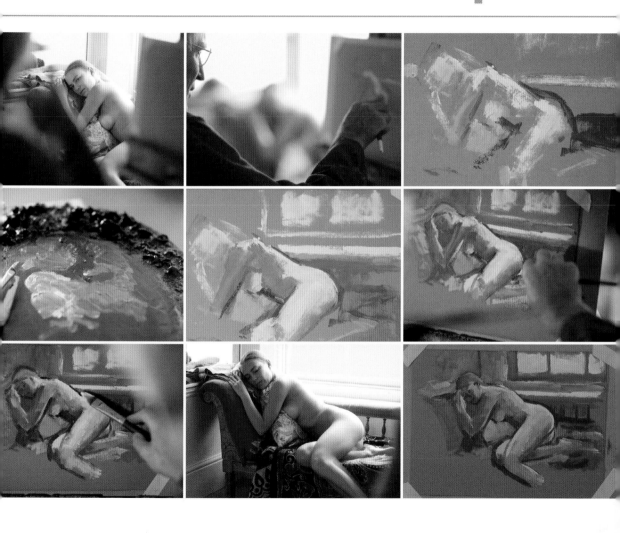

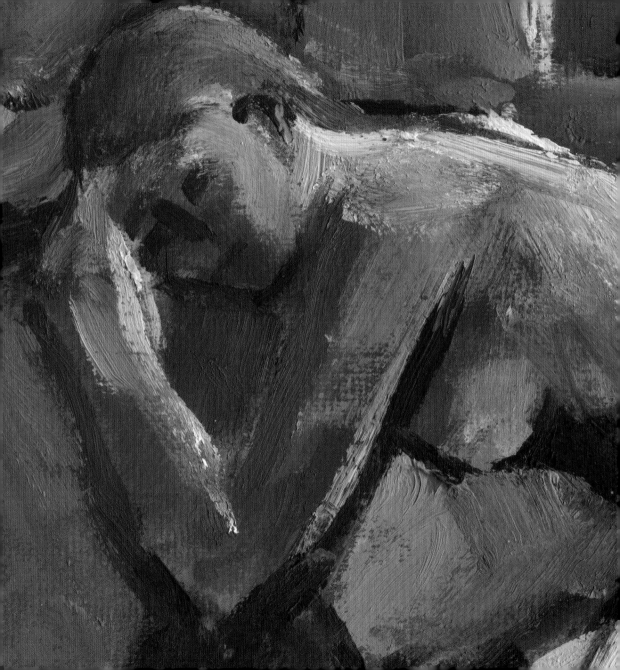

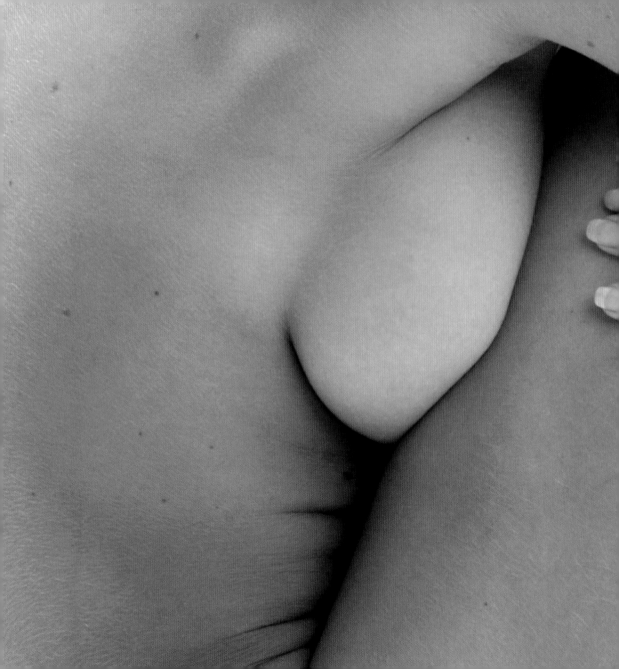

studio figure reference

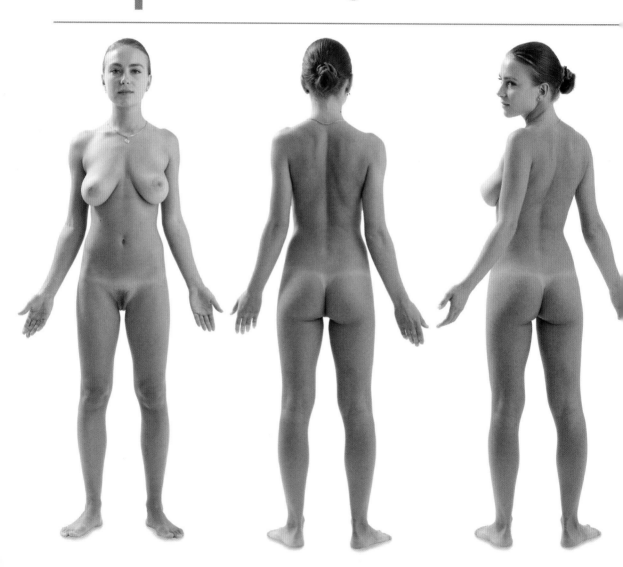

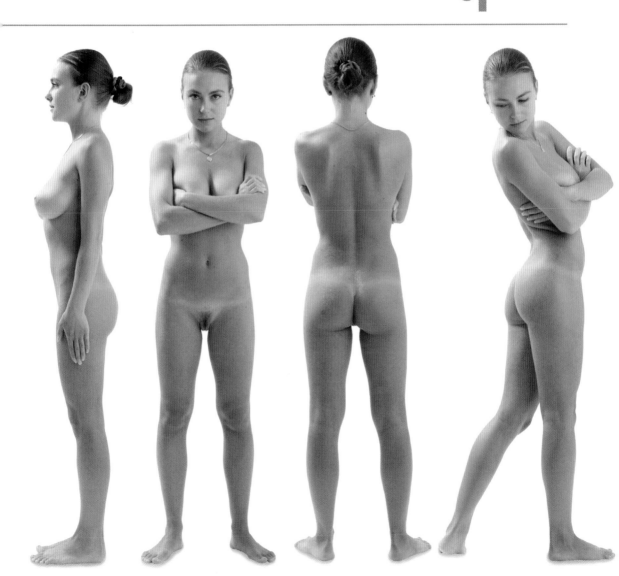

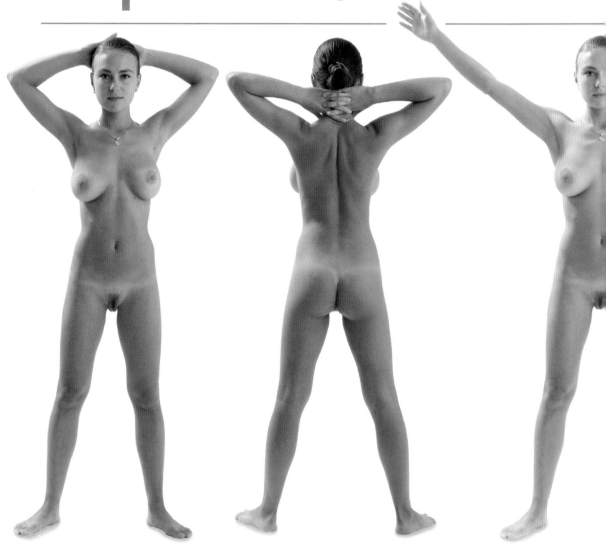

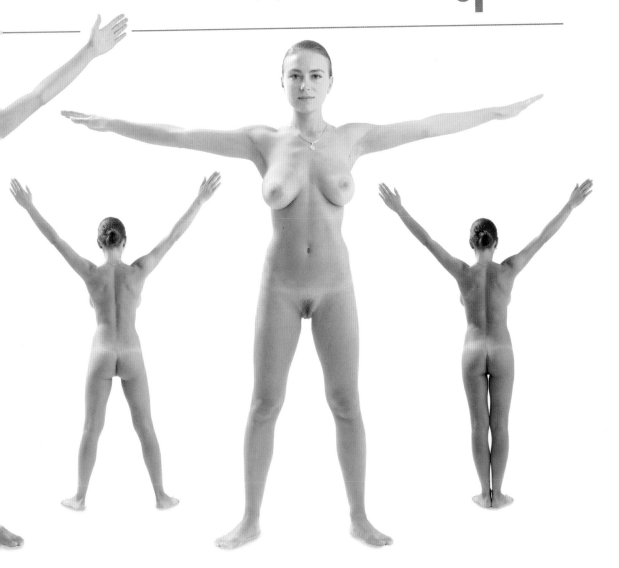

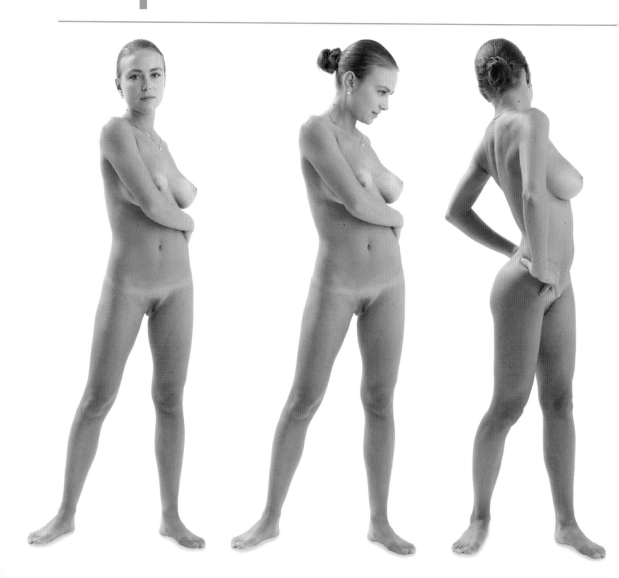

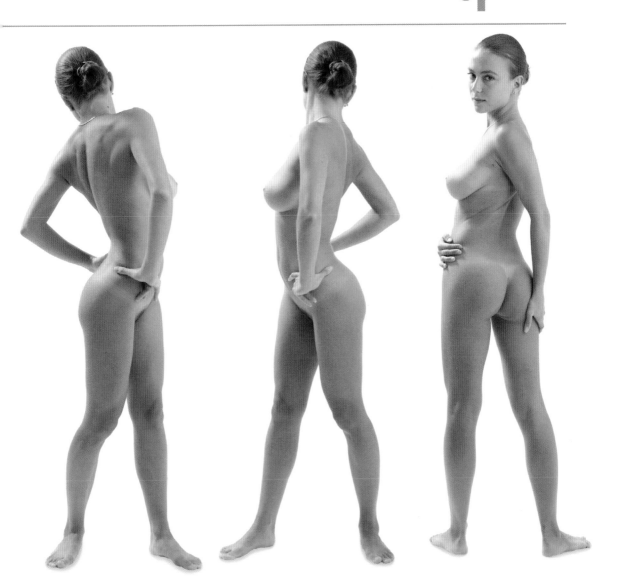

Female: walking

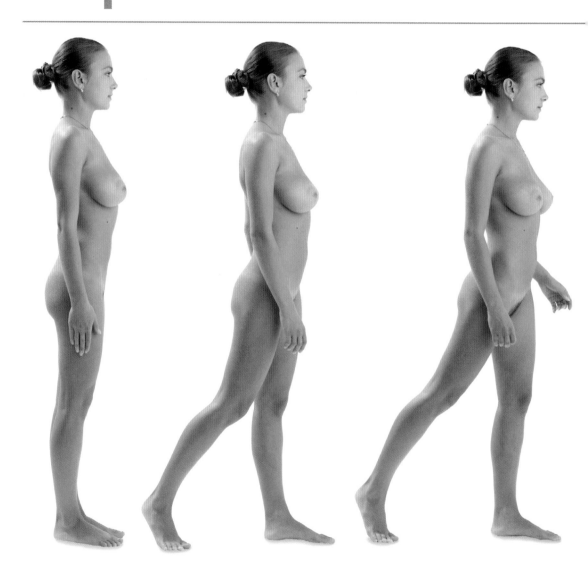

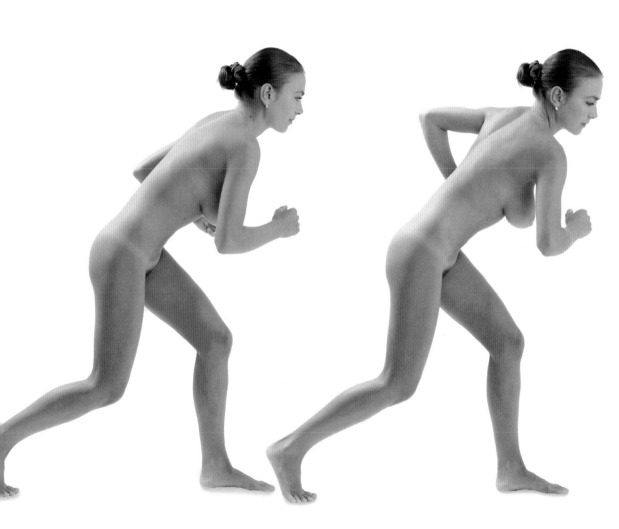

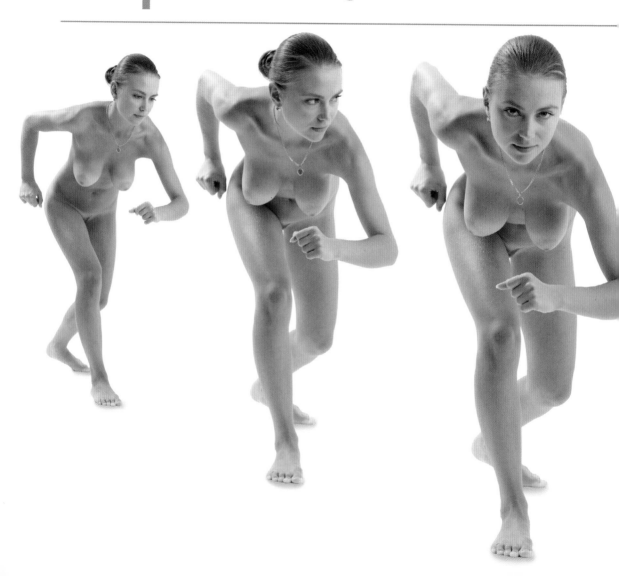

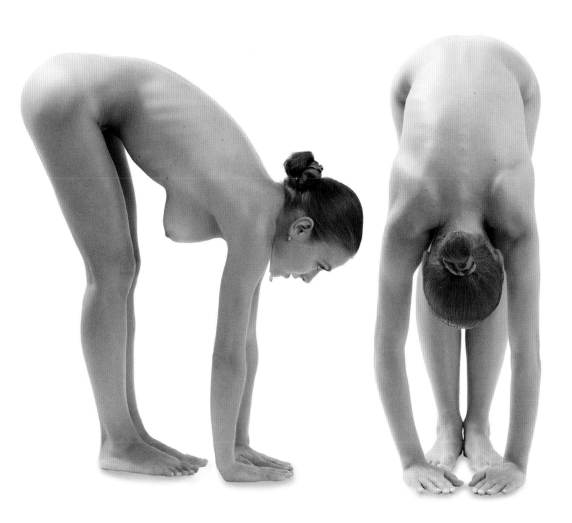

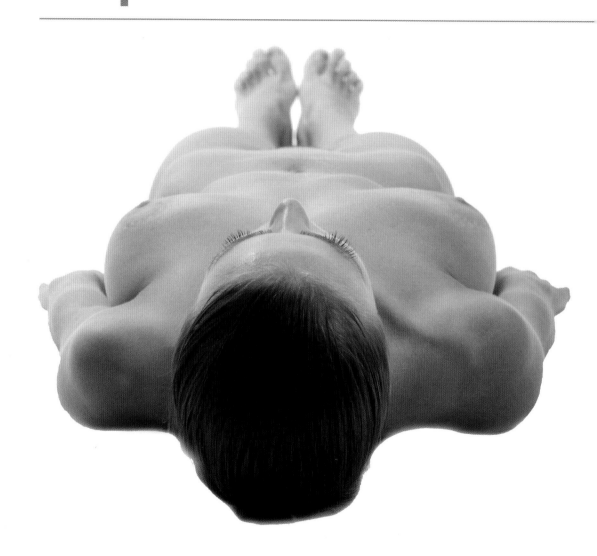

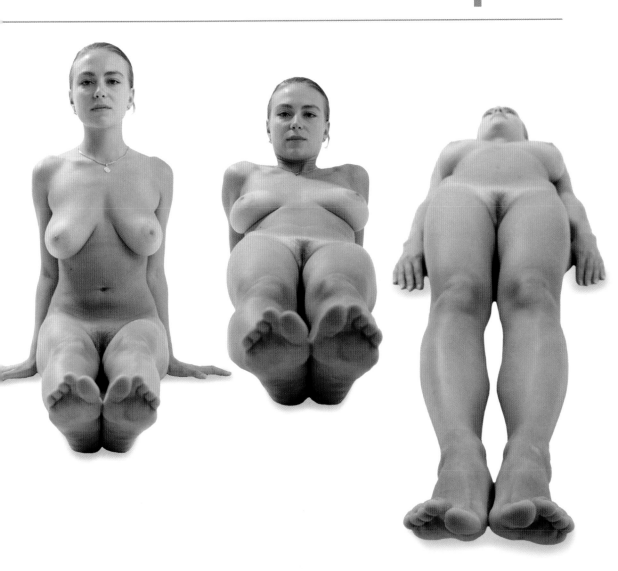

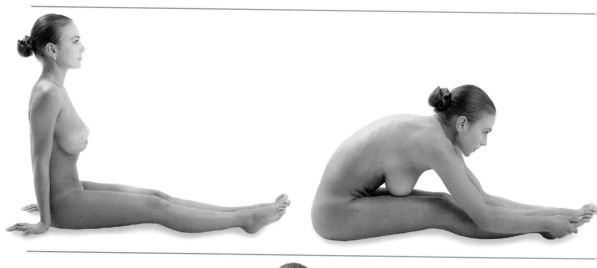

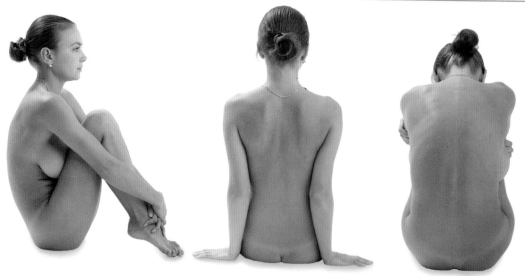

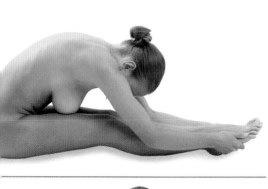

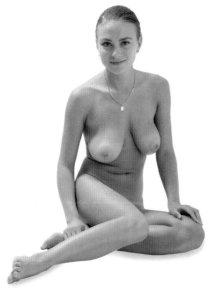

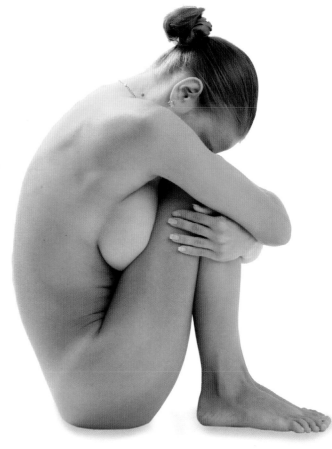

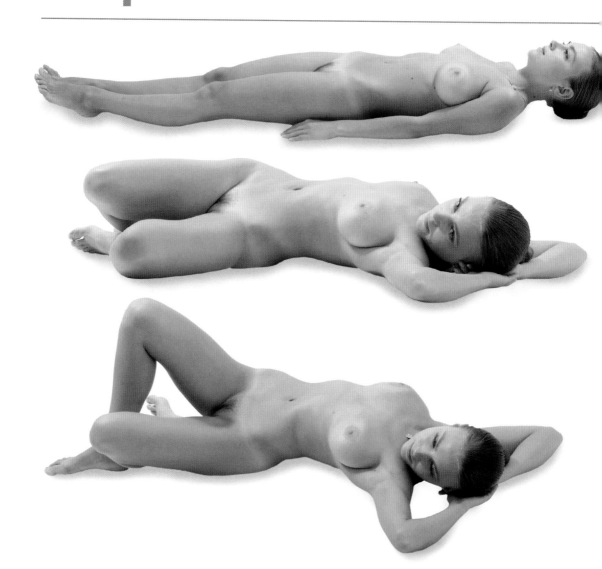

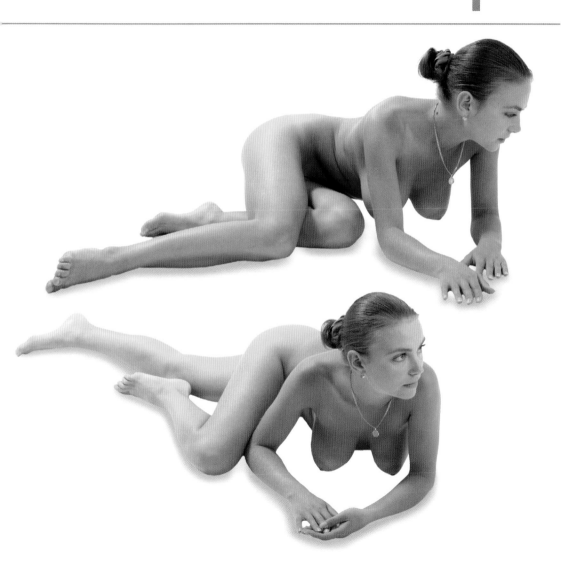

Female: seated profile

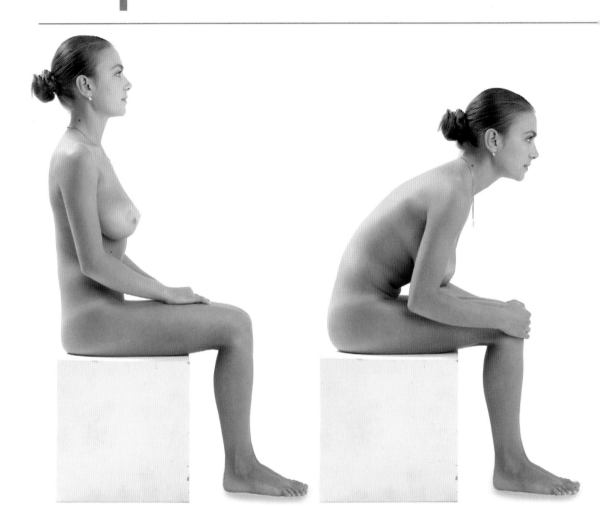

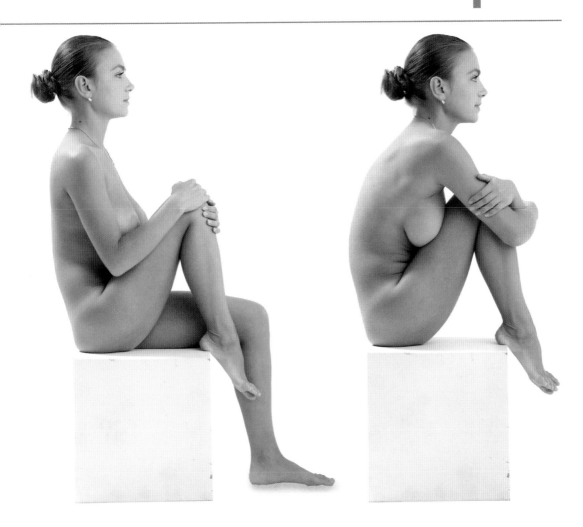

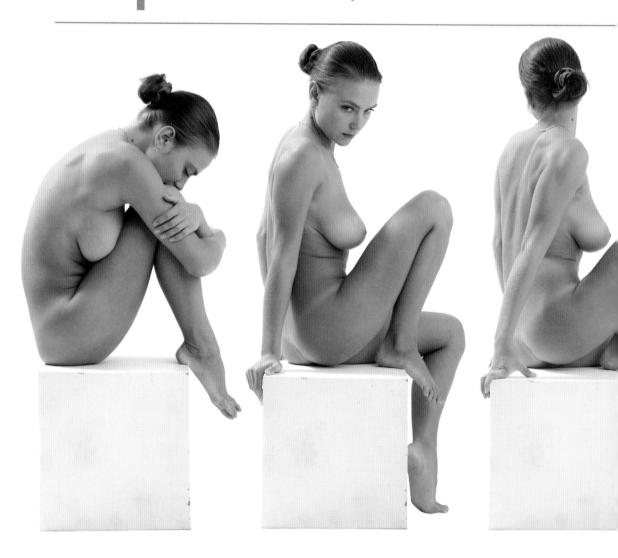

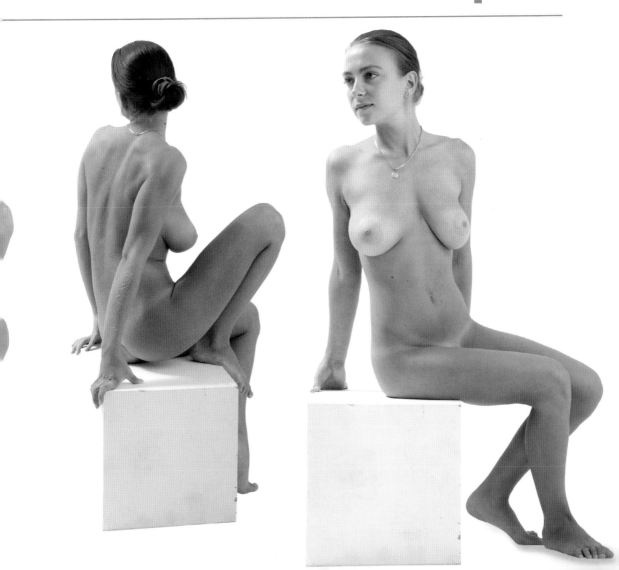

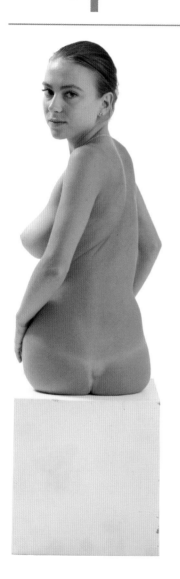
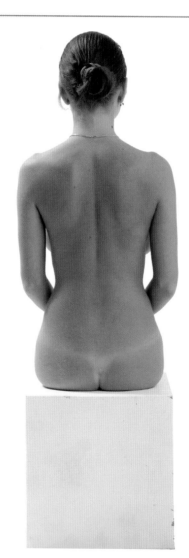
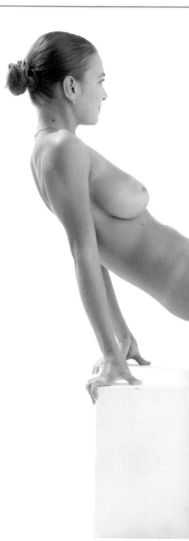

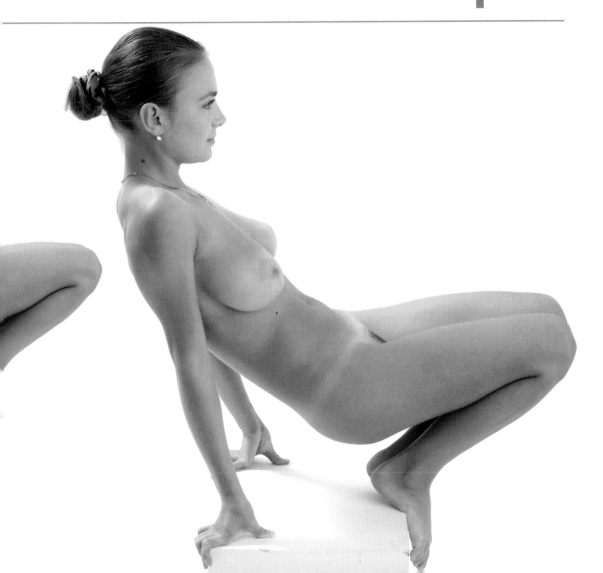

Female: seated high

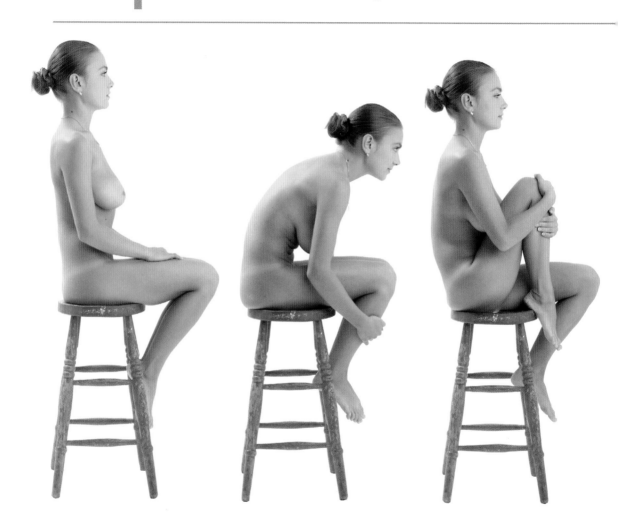

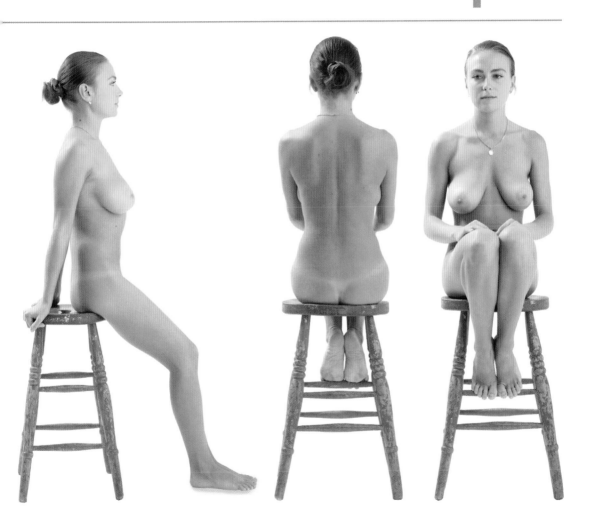

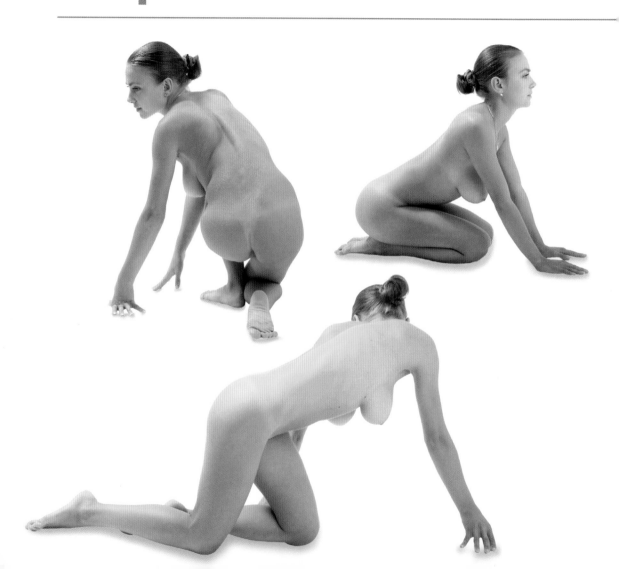

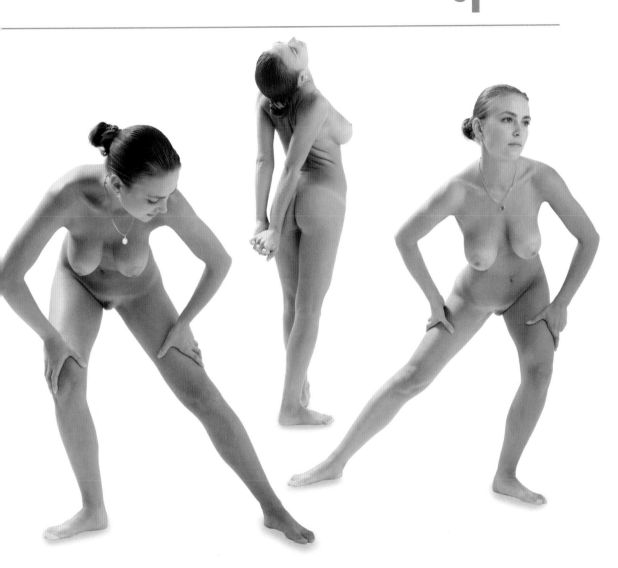

Female: shape and drama

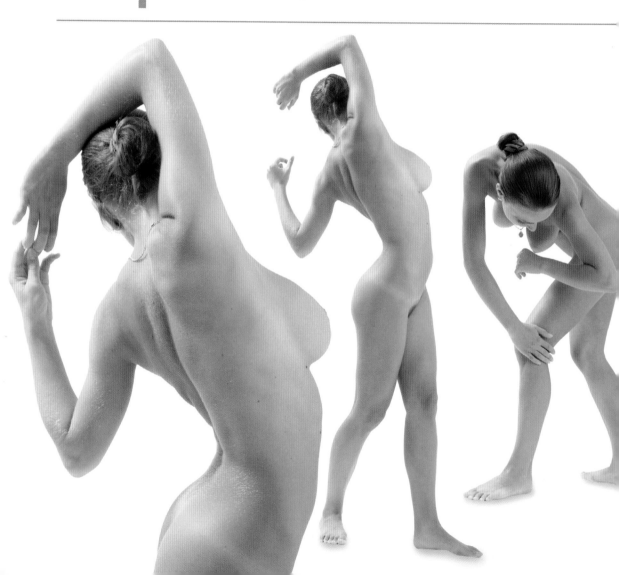

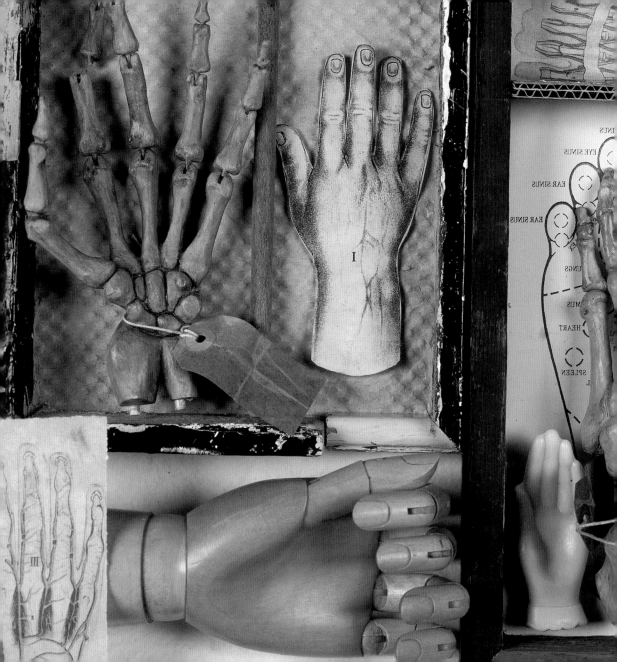

I

III

INS

EYE SINUS

EAR SINUS

EAR SINUS

UNGS

MUS

HEART

SPLEEN

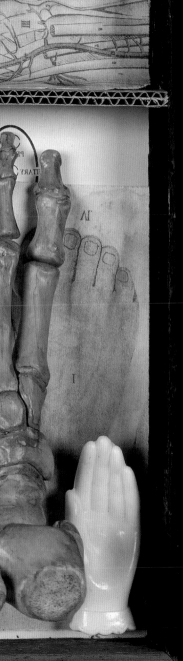

hands
and feet

130 Hands: shape and proportion

Although the basic proportion of the hand and the relationship of the fingers is similar from individual to individual, the shape and appearance alters dramatically depending on viewpoint.

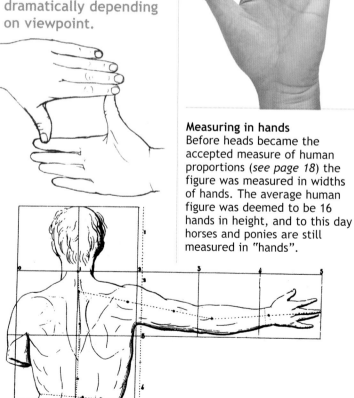

Measuring in hands
Before heads became the accepted measure of human proportions (*see page 18*) the figure was measured in widths of hands. The average human figure was deemed to be 16 hands in height, and to this day horses and ponies are still measured in "hands".

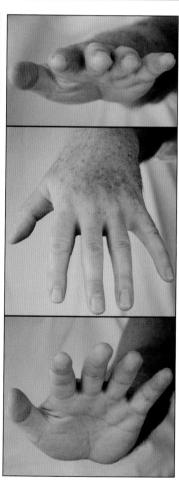

Shape varies on the angle viewed.

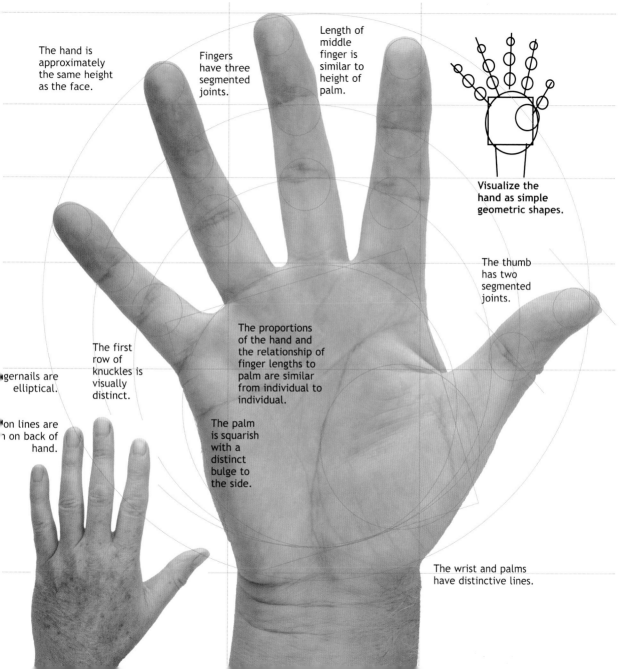

The hand is approximately the same height as the face.

Fingers have three segmented joints.

Length of middle finger is similar to height of palm.

Visualize the hand as simple geometric shapes.

The thumb has two segmented joints.

The proportions of the hand and the relationship of finger lengths to palm are similar from individual to individual.

The first row of knuckles is visually distinct.

gernails are elliptical.

on lines are n on back of hand.

The palm is squarish with a distinct bulge to the side.

The wrist and palms have distinctive lines.

132 Palm and thumbs

The human hand is basically a bundle of sticks (bones) bound together with elastic bands (tendons), and upholstered with padded flesh, covered with skin.

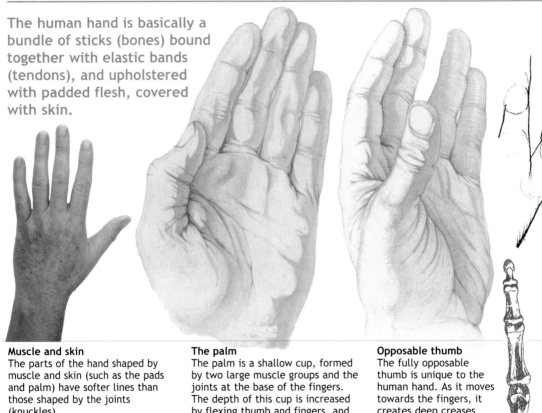

Muscle and skin
The parts of the hand shaped by muscle and skin (such as the pads and palm) have softer lines than those shaped by the joints (knuckles).

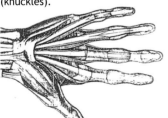

The palm
The palm is a shallow cup, formed by two large muscle groups and the joints at the base of the fingers. The depth of this cup is increased by flexing thumb and fingers, and large folds of skin trace well-defined lines.

Opposable thumb
The fully opposable thumb is unique to the human hand. As it moves towards the fingers, it creates deep creases across the large group of muscles at the base of the thumb.

Back of the hand
The back of a closed hand is slightly convex and virtually featureless. When the hand is seen flat, subtle indications of the veins and tendons appear. However, an elderly hand may be more distinct and rugged, with raised veins and features.

Fingers
The fingers differ in length, and when the muscles are relaxed they tend to curve inward. You can only keep your fingers straight under tension with effort. Finger tips are not always round or symmetrical. Creases at joints rarely align neatly with those on neighbouring fingers.

Finger joints
When the fingers are bent, the knuckles are sharply defined, but when you straighten your fingers the slack skin over the joints forms into deep folds and creases.

Look closely at hands, and see how the fingernails vary in shape and size and how the fingers differ in length. This difference is even more pronounced from individual to individual, according to age, sex, and ethnic group. Finger tips are not always round or symmetrical and the sides of the nail may be straight, but the root and tip are invariably curved. Fingers and fingernails, despite their small size, provide us with a wealth of information, and impart character to studies of the hand.

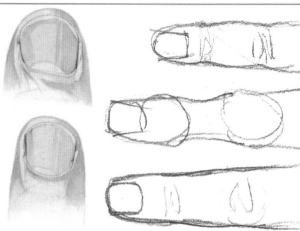

Individual fingers Typical finger shapes

Shape
Note how the shape of a person's finger tends to reflect the overall shape of the hand.

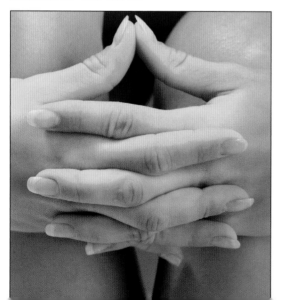

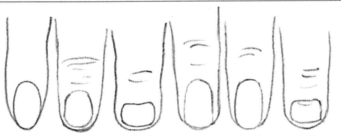

Nail shapes Typical fingernail shapes are square, round, and elliptical.

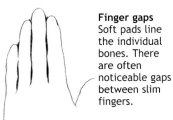

Finger gaps
Soft pads line the individual bones. There are often noticeable gaps between slim fingers.

Bulging finger tips
True-to-life drawings will include such details as the fleshy finger tips of a person who habitually chews his or her nails.

Proportions
Make some quick studies to discover for yourself the wide variety of proportions. There is clearly no such thing as the standard finger and nail. Note how character and gender are implied by the fingernails.

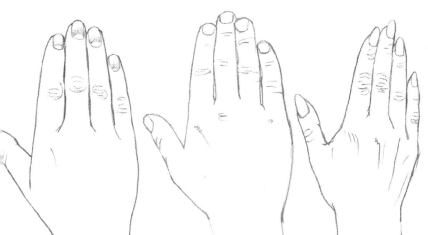

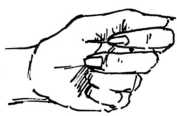

It sometimes helps to make quickly drawn, analytical studies that reduce the hand to basic geometric forms in order to explore its shape, form, and volume.

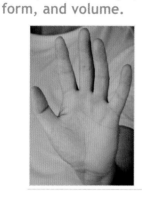

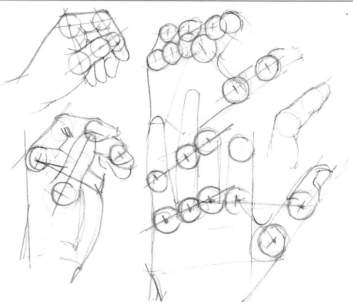

Simple shapes
Reduce the hand to simple shapes. Visualize the knuckle joints as spheres, and depict them as circles in your preliminary drawings. Then join them by tangential lines to represent the cylinders and cones that make up the finger shapes.

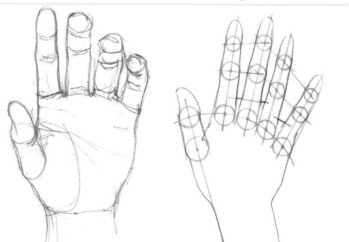

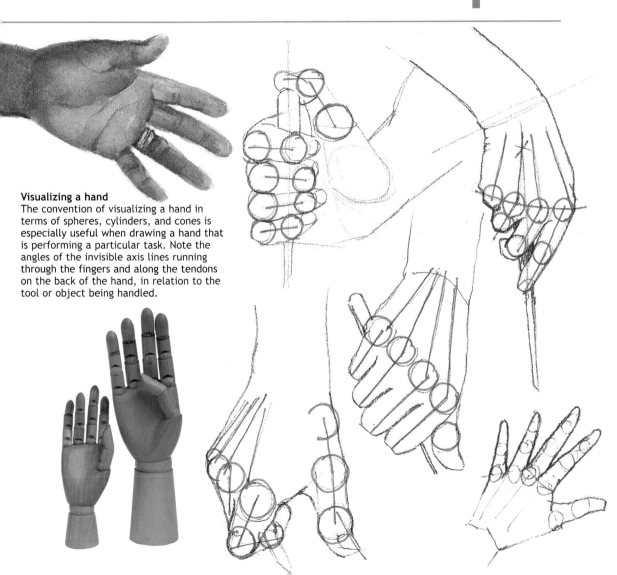

Visualizing a hand
The convention of visualizing a hand in terms of spheres, cylinders, and cones is especially useful when drawing a hand that is performing a particular task. Note the angles of the invisible axis lines running through the fingers and along the tendons on the back of the hand, in relation to the tool or object being handled.

138 Form and volume

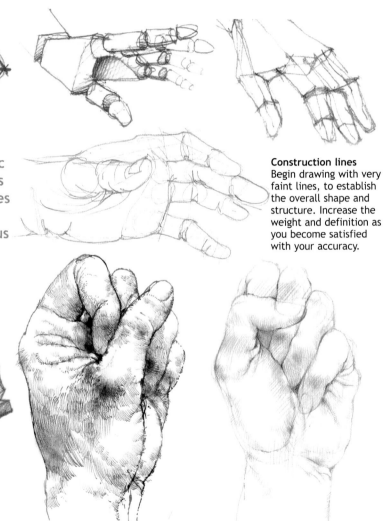

Another way of understanding the basic structure of the hand is to visualize it as a series of flat planes. This exercise helps you focus your attention on the way light falls on the hand, and creates a crude, but surprisingly convincing, illusion of three dimensions.

Construction lines
Begin drawing with very faint lines, to establish the overall shape and structure. Increase the weight and definition as you become satisfied with your accuracy.

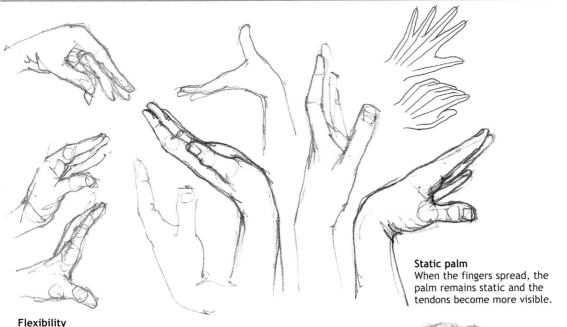

Static palm
When the fingers spread, the palm remains static and the tendons become more visible.

Flexibility
The wrist is extremely flexible, and fingers have a large range of movements in all directions. The bones that run from the wrist to the base of the fingers are more or less fixed in relation to one another. No change of shape is possible, except for a very slight lateral curvature across the palm of the hand.

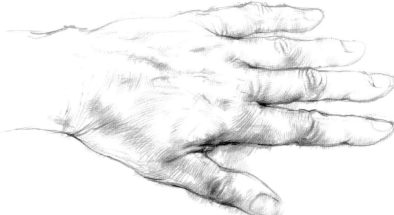

140 | Hands in action

These fast sketches show variations on a common theme: the gripping and holding hand.

To capture the sometimes fleeting movement of hands in action, develop the knack of putting down what you see using a fast, economical style.

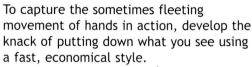

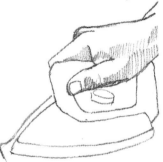

Pay attention to the relationship of the fingers as the hand grips objects; note how the hand displays degrees of tension and pressure, depending on what it is doing.

Relaxed grip When a hand holds a staff or pole upright (*above*), it appears perfectly relaxed, with the muscles used almost at rest.

Fingers together The fingers of this hand (*below left*) are squeezed together by the effort of gripping an object that is too large for it to encircle. The only way it can exercise control is by using the friction between the skin and the surface of the object held.

Pressing down When pressing clothes (*above*), the inside of the finger and the soft pad of the thumb are flattened against the handle of the iron. The muscle between the thumb and index finger swells with the pressure used.

Thumb pressure When gripping a narrow object (*below*), the thumb is used to counterbalance the action of the fingers. This action is used for peeling potatoes or whittling wood.

Exerting control When operating a lever (*above*), the fingers exert control, rather than grip the object firmly. You will notice the exaggerated angle of the wrist in this position.

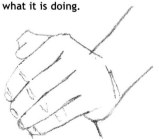

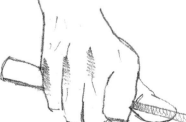

When attempting to depict a hand applying pressure, work fairly quickly to get the general shape and outline.

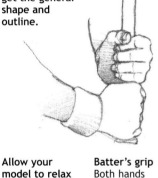

Allow your model to relax frequently; and then to apply pressure for short periods, while you draw in the details, such as the tendons and muscles.

Batter's grip
Both hands employ a similar grip for this sporting activity.

Hammer and chisel
Typically, the hands utilize different grips for this sort of activity.

Firm grip
The pose is similar to operating a lever, but the closing of the gaps between the fingers indicates a tighter grip.

Sensitive control
When you pick up small objects, your hand adopts an elegant pose. The index finger and thumb do the work; the other fingers are held out of the way, balancing the hand (*below*).

Finger-tip pressure
Finger tips alone (*above*) can exert sufficient pressure to prevent a delicate object dropping from this hand's grasp.

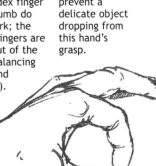

Watch how people hold their glasses in a bar or at a party. Their hands are often seen delicately gripping the stem of a wineglass or cradling a goblet.

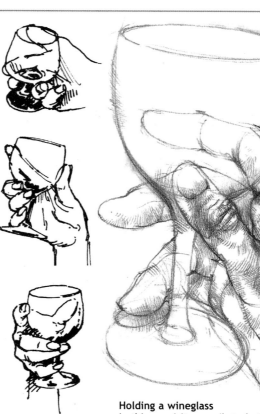

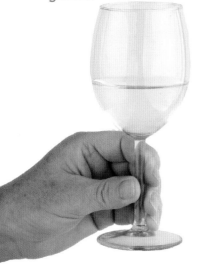

Quick studies
A fibre-tip pen on smooth paper was used for these preliminary studies (*right*).

Holding a wineglass
In this exquisite pencil study (*above*), depth is suggested by the use of strong hatching in the foreground. The fingers behind the glass are merely hinted at with fine linework.

A hand holding a pencil is a familiar pose; familiarize yourself with this everyday action by drawing it from different viewpoints. It is important to create a sense of the hand resting firmly on the writing surface.

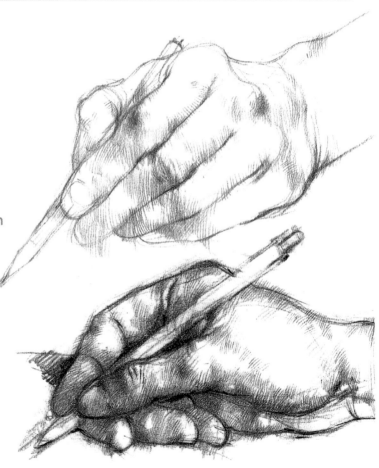

Close observation
The artist used a mirror to make this coloured-pencil drawing (*above right*) of his own hand. In the detailed graphite pencil study of a writing hand (*right*), see how the fingers are pressed against the table. The muscles of the palm are compressed by the hand's weight.

Keep a sketchbook of your friends and family performing everyday tasks. This will develop your ability to make rapid, yet accurate, visual notes.

Combining studies
If your subject is constantly moving, drawing very familiar actions can be a challenging and sometimes frustrating exercise. Be prepared to abandon one drawing for another as the action dictates, perhaps combining several studies at a later stage to make one finished drawing.

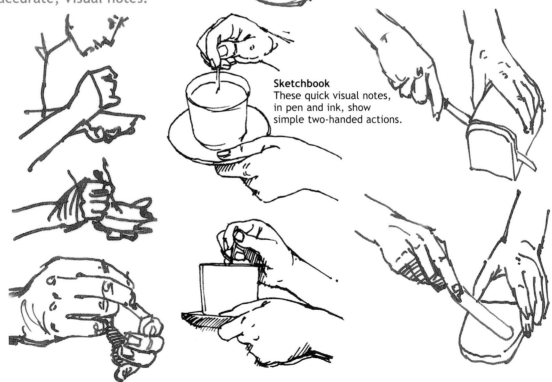

Sketchbook
These quick visual notes, in pen and ink, show simple two-handed actions.

Hands on the move

Watching musicians perform offers an ideal opportunity for making studies of unusual poses. Unfortunately, a musician's hands are constantly on the move and work independently of one another – perhaps a good case for using photographs as reference material.

Pairs of hands

When you are drawing pairs of hands at rest or working together, pay particular attention to the proportions. In most cases, both hands belong to the same person, so they should share the same characteristics.

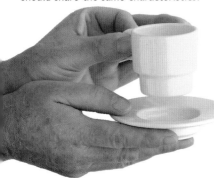

Relationship of fingers and hands

Threading a needle requires dexterity and concentration. The artist has managed to convey these qualities in a simple line drawing (*right*) that relies on reproducing the precise relationship between fingers and hands that is required by the task.

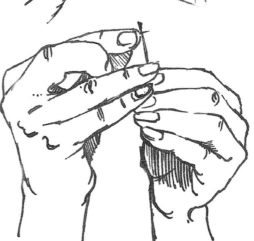

146 | Hands and character

A pair of hands may tell you much about a person - whether they have had to struggle to make a living, or maybe have led a protected life. Some hands will have grown older unmarked, while others are gnarled and twisted by manual work, wear, and ill-health.

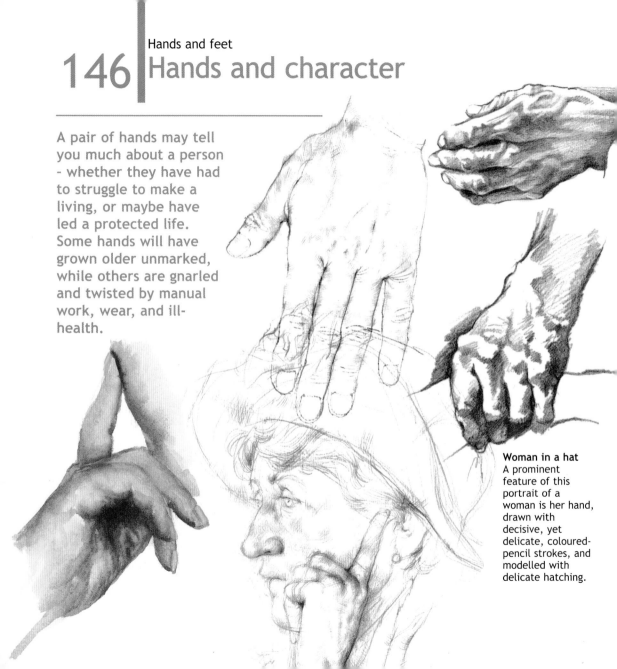

Woman in a hat
A prominent feature of this portrait of a woman is her hand, drawn with decisive, yet delicate, coloured-pencil strokes, and modelled with delicate hatching.

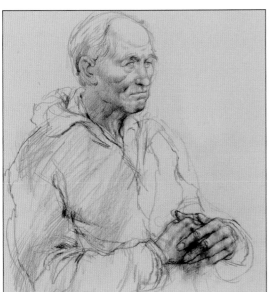

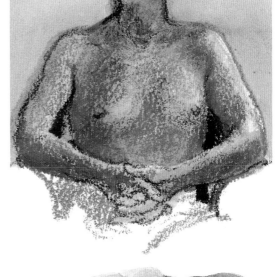

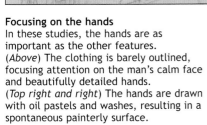

Focusing on the hands
In these studies, the hands are as important as the other features.
(*Above*) The clothing is barely outlined, focusing attention on the man's calm face and beautifully detailed hands.
(*Top right and right*) The hands are drawn with oil pastels and washes, resulting in a spontaneous painterly surface.

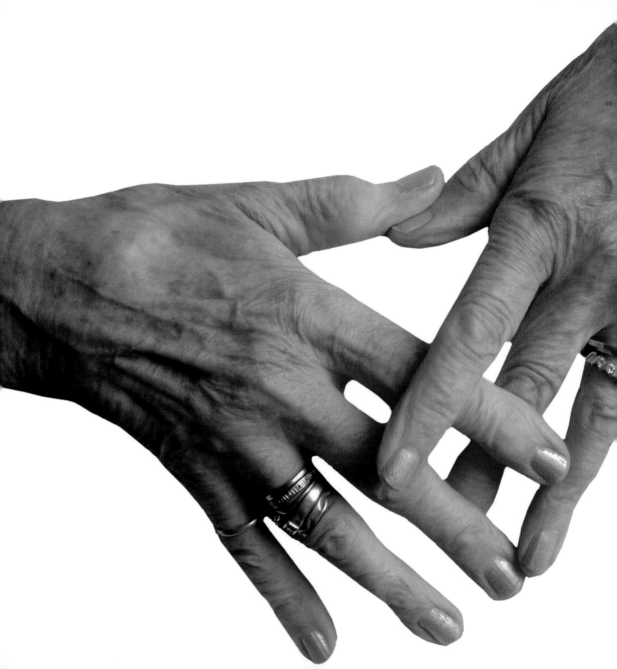

Bringing out the character
Folds, creases, and veins are much more prominent in older hands. Use these features to bring out the personality of the hands and, from them, that of the person.

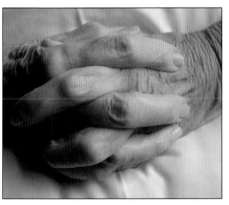

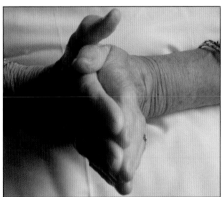

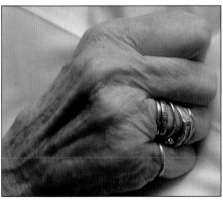

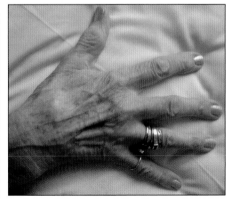

Implying the surface detail of a hand can be a taxing exercise. A mass of delicate creases, soft shadows cast by tendons and veins, and even a covering of fine hair, all help define a hand's unique character and shape.

Character
As with faces and bodies, hands have characteristics that are unique to the individual. Older hands are full of character and experience.

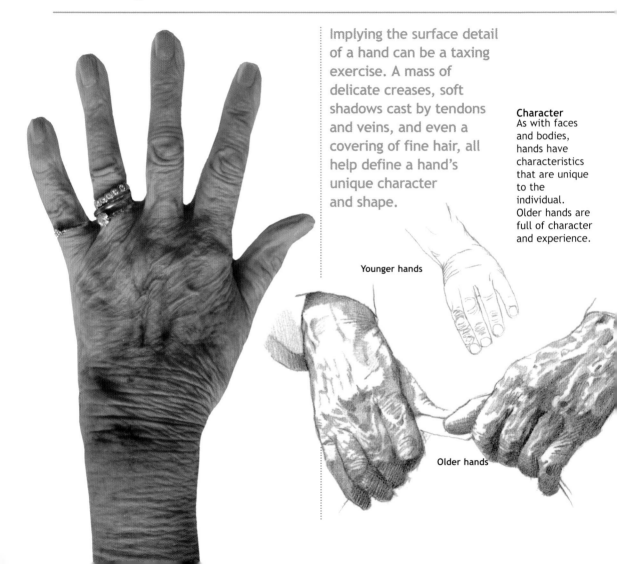

Younger hands

Older hands

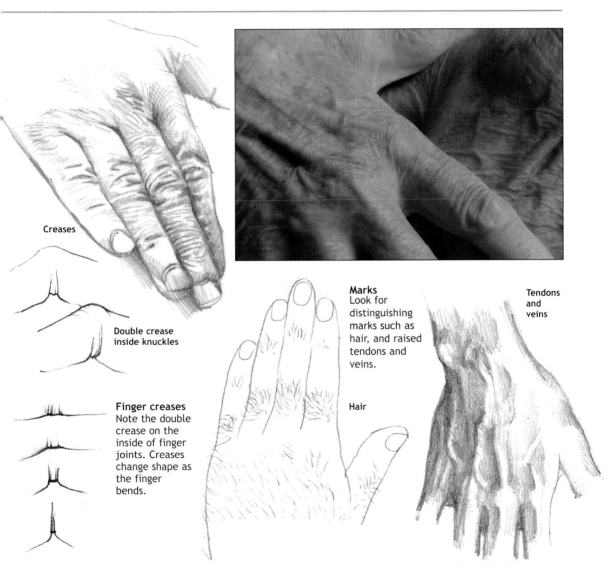

Creases

**Double crease
inside knuckles**

Finger creases
Note the double
crease on the
inside of finger
joints. Creases
change shape as
the finger
bends.

Marks
Look for
distinguishing
marks such as
hair, and raised
tendons and
veins.

Hair

**Tendons
and
veins**

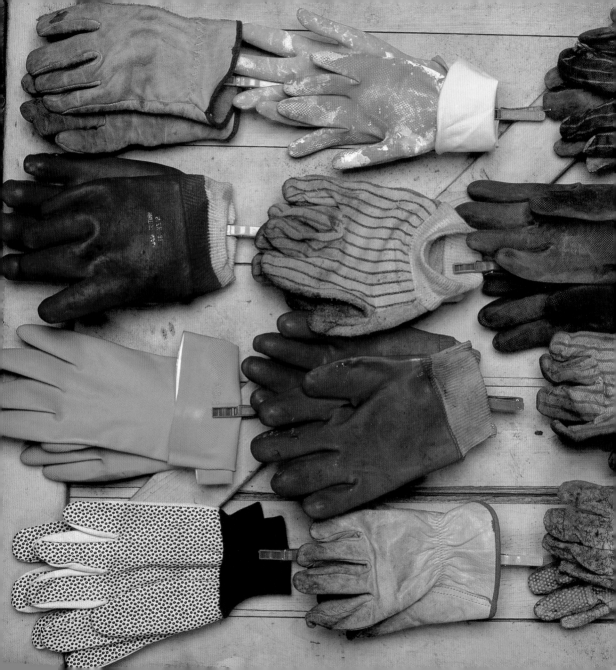

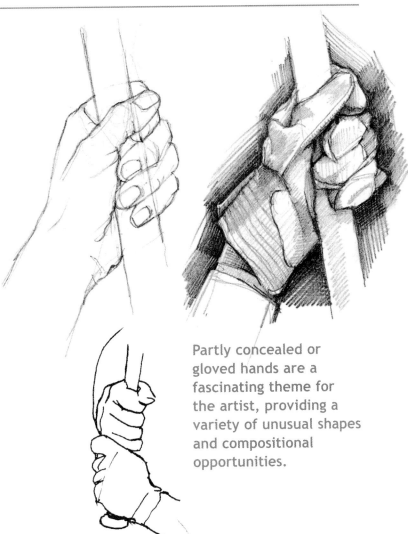

Partly concealed or gloved hands are a fascinating theme for the artist, providing a variety of unusual shapes and compositional opportunities.

Apart from their colour and texture, tight-fitting gloves are little more than a second skin, and display similar creases and bulges to those of the naked hand. However, drawing industrial gauntlets, catcher's mitts, or boxing gloves, for example, is a whole new challenge. These gloves disguise the natural shape of the hand, so force the artist to look closely to discover the structure beneath.

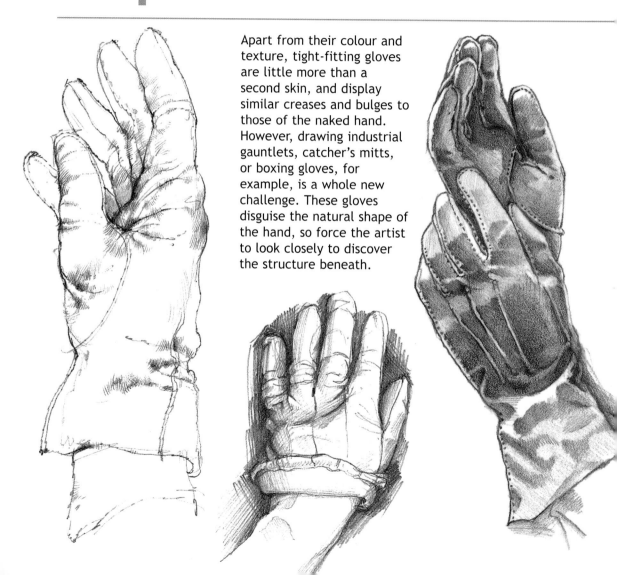

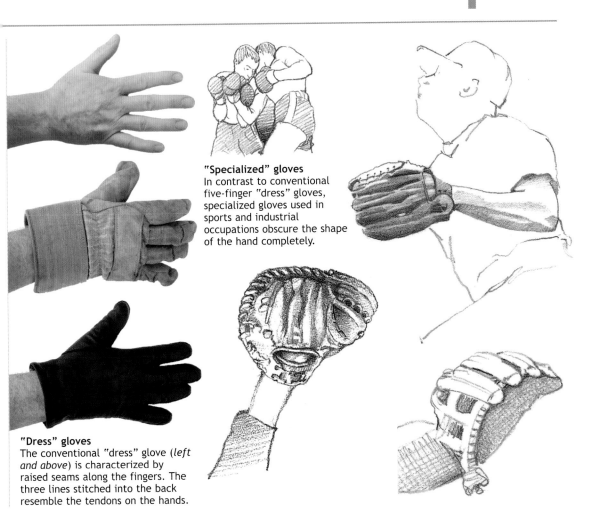

"Specialized" gloves
In contrast to conventional five-finger "dress" gloves, specialized gloves used in sports and industrial occupations obscure the shape of the hand completely.

"Dress" gloves
The conventional "dress" glove (*left and above*) is characterized by raised seams along the fingers. The three lines stitched into the back resemble the tendons on the hands.

Arms and hands are able to take more positions than any other part of the body. You can use the contrast with the less supple torso to give variety to your drawings. When setting up a pose or observing a subject, keep looking for angles that add interest and tension to your work.

Media
Arms are a good su
for trying out simila
"pointed" media, s
as graphite pencils,
charcoal pencils, a
artists' crayons. Va
your technique, an
experiment with
different textures.

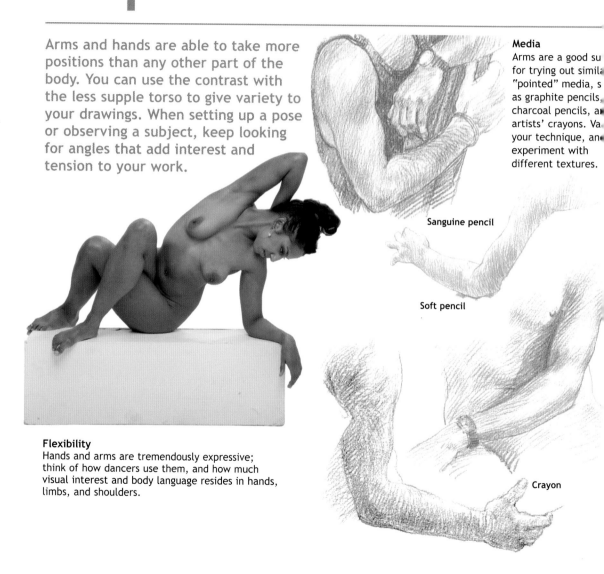

Sanguine pencil

Soft pencil

Crayon

Flexibility
Hands and arms are tremendously expressive; think of how dancers use them, and how much visual interest and body language resides in hands, limbs, and shoulders.

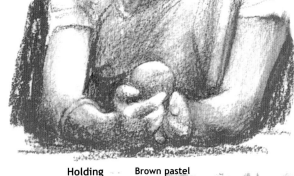

Holding
Get the hands to do something when setting up a pose. Do not be afraid to introduce simple props, such as the pole and tennis ball employed in these two poses.

Brown pastel

Observation
Do not neglect the hands; many a figure study has been spoilt by poorly observed hands

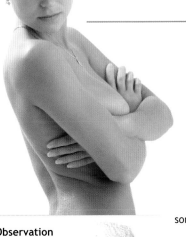

that have simply been added to the ends of the arms as weak appendages.

Hand studies in graphite pencil and charcoal pencil

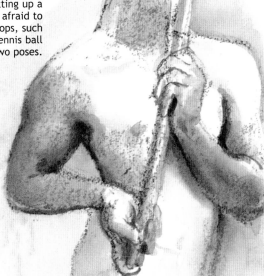

Oil pastel with watercolour wash

In most situations, unlike the hand, the human foot is hidden. When revealed in the life room, or on the beach, for example, the form and character of the foot is often surprising, yet has a lot in common with that of the hand.

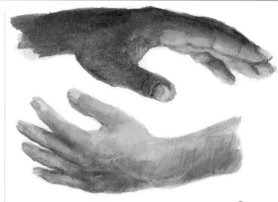

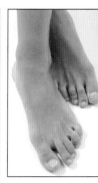

Personality
Feet also express individuality and can convey a lot of information about the personality of the model.

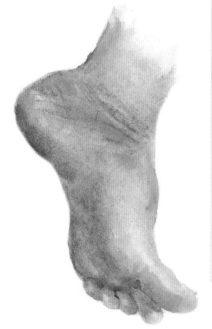

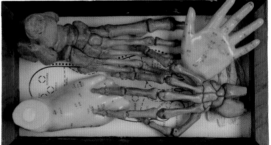

Three-dimensional reference
The structure of the foot has a lot in common with the hand.

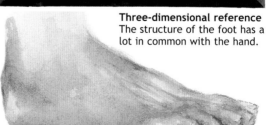

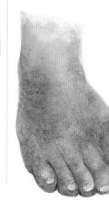

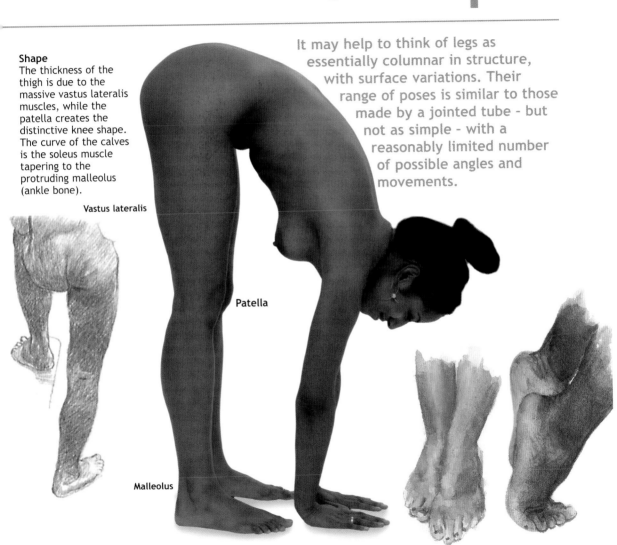

Shape
The thickness of the thigh is due to the massive vastus lateralis muscles, while the patella creates the distinctive knee shape. The curve of the calves is the soleus muscle tapering to the protruding malleolus (ankle bone).

Vastus lateralis

It may help to think of legs as essentially columnar in structure, with surface variations. Their range of poses is similar to those made by a jointed tube – but not as simple – with a reasonably limited number of possible angles and movements.

Patella

Malleolus

hands
reference

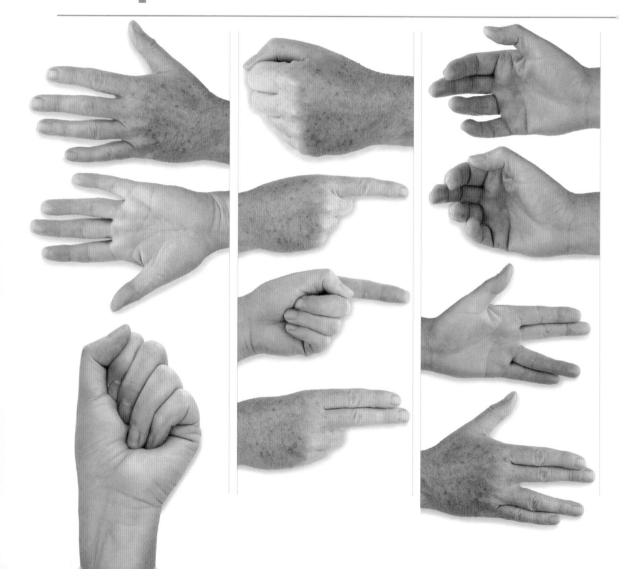

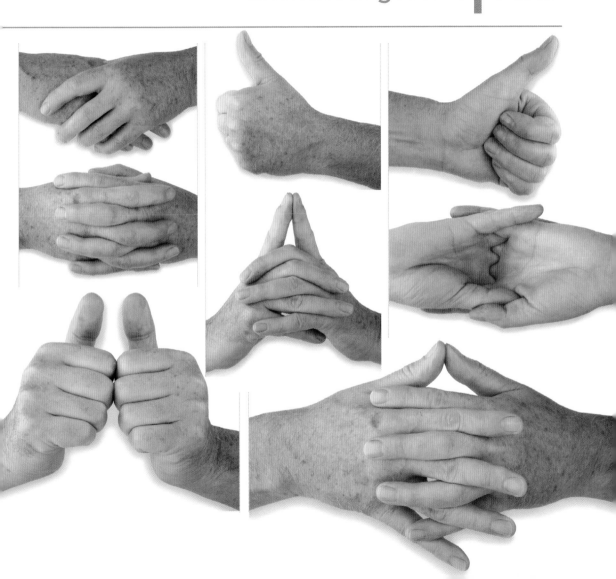

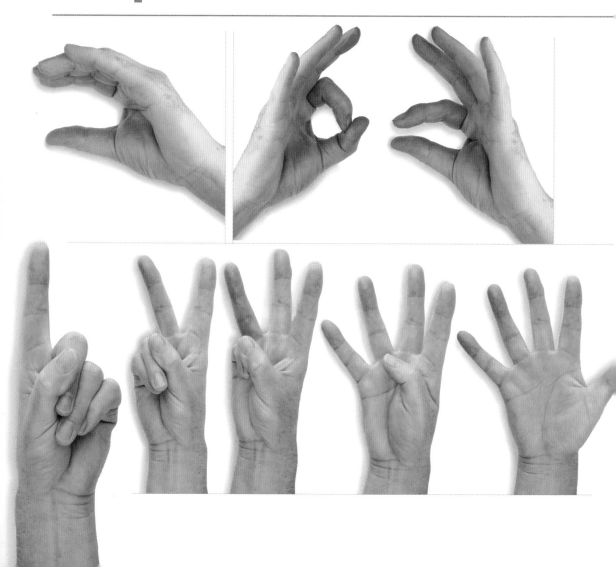

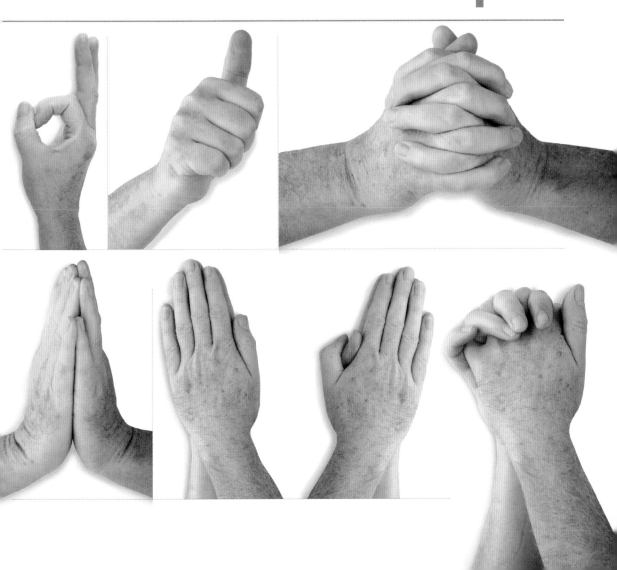

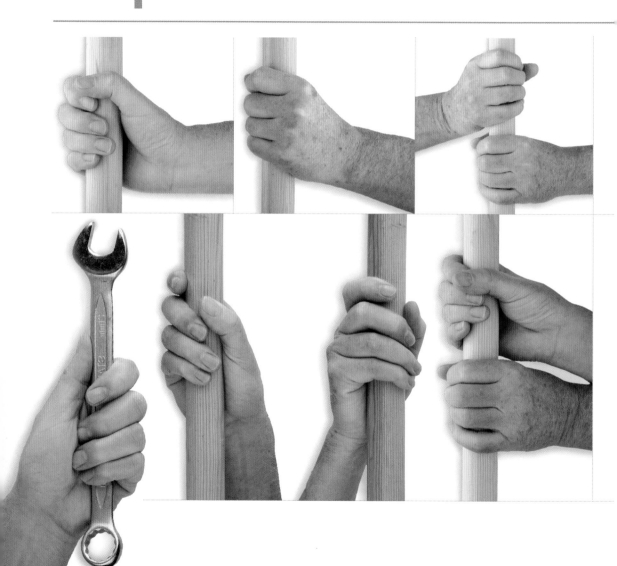

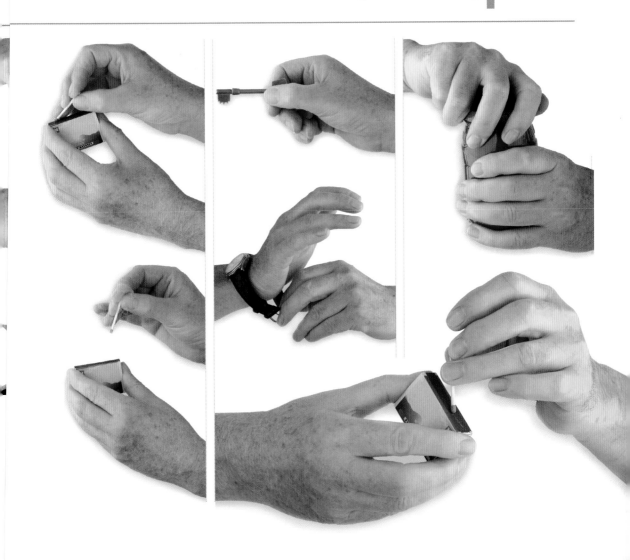

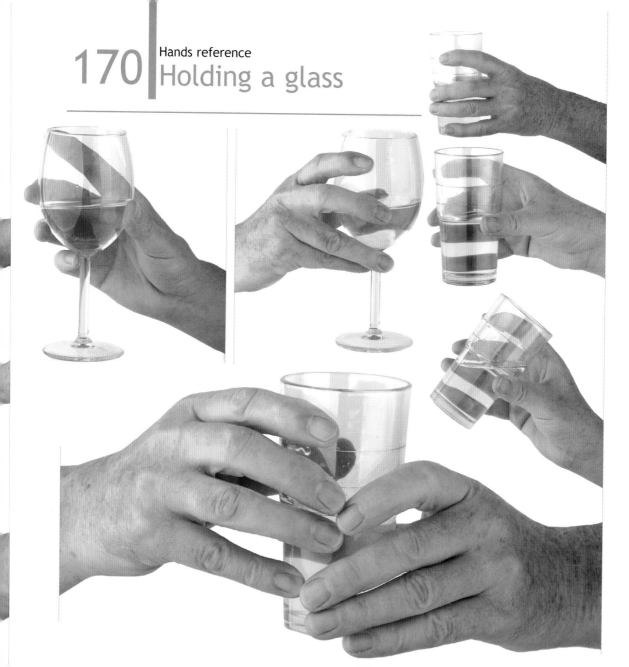

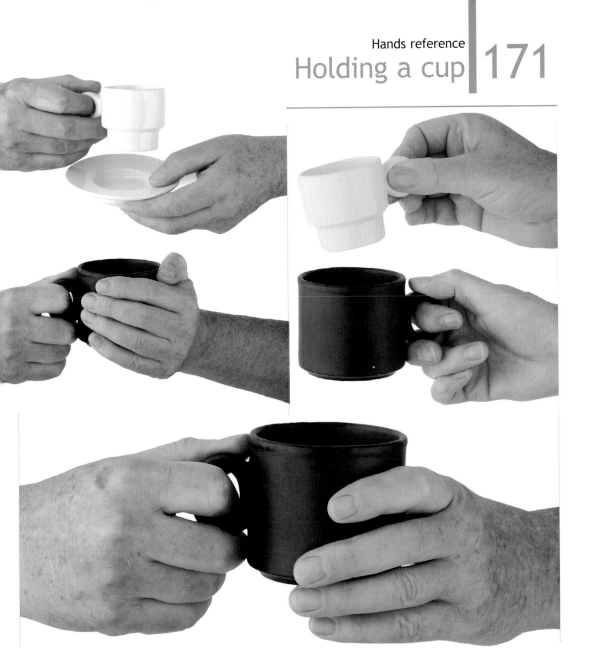

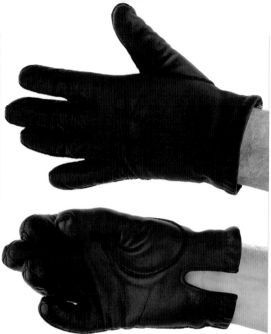

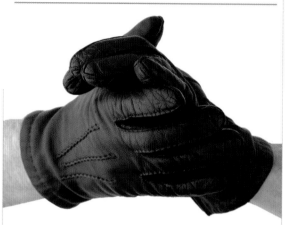

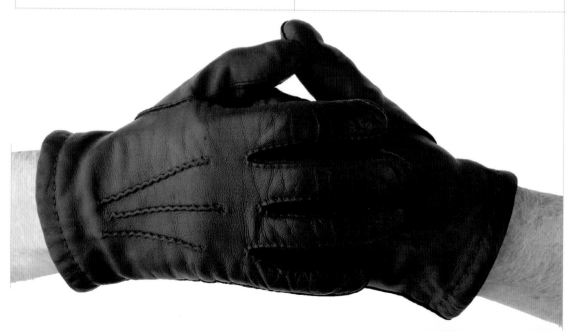

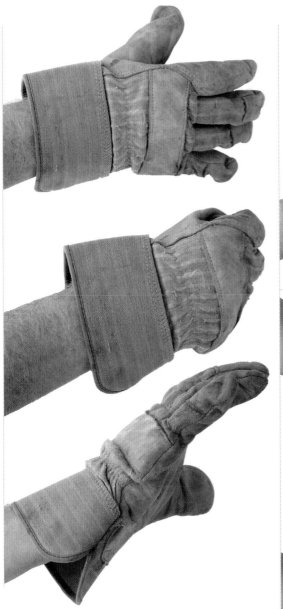

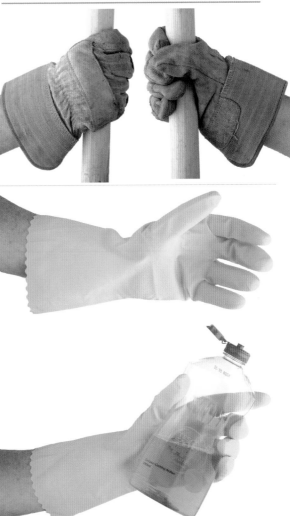

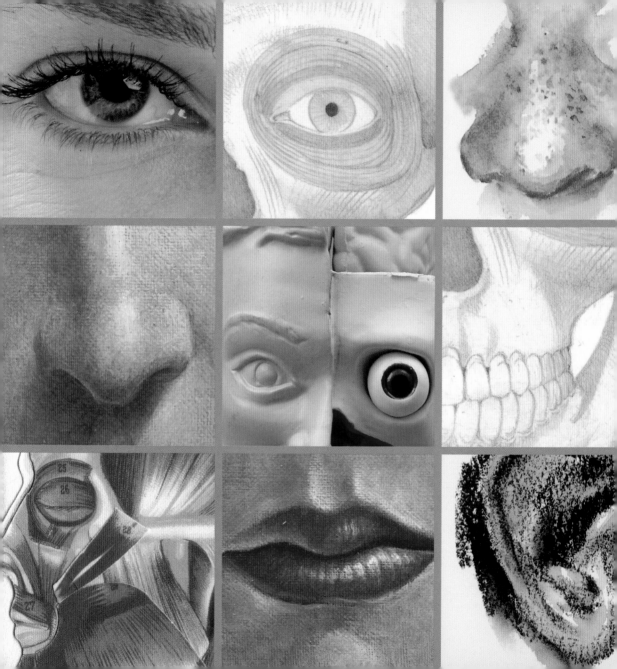

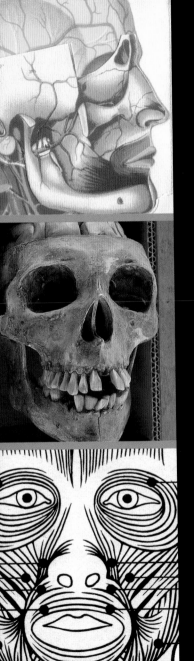

heads
and faces

When face to face with another human being, you are automatically drawn to make eye contact. The same reaction often encourages an artist to begin a portrait by drawing the eyes – perhaps one of the hardest ways to get going. Resist the temptation to focus on the details and instead concentrate on the overview.

Taking an overview
Look for the overall shape of the head; think about the shape of the skull. Look for the relationship between the various planes of the person's features until you have created a solid foundation upon which to build.

Head size and proportions
In general, the size of the head is one eighth of the total height of the person. The bottoms of the eye sockets are about halfway up the head.

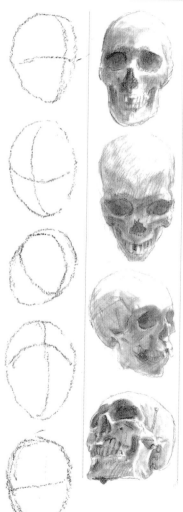

Shape
The skull determines the overall shape of the head. The muscles that lie beneath the skin of the face, scalp, and neck create the facial expressions that give movement and character to each individual.

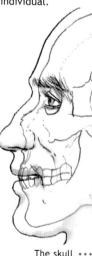

The skull ••••
determines size
and shape.

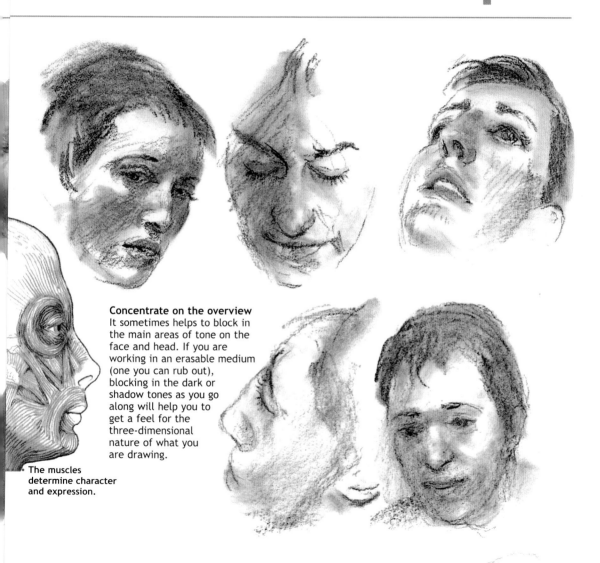

Concentrate on the overview
It sometimes helps to block in the main areas of tone on the face and head. If you are working in an erasable medium (one you can rub out), blocking in the dark or shadow tones as you go along will help you to get a feel for the three-dimensional nature of what you are drawing.

The muscles determine character and expression.

The best way to approach the task of capturing skin colour is to build up the total picture gradually, by careful observation of the complexion and features of the person. Short cuts, such as filling in with flat colour for skin tones, is fairly ineffective and often looks unrealistic.

Charcoal and pastel
Drawing softened with a paper stump.

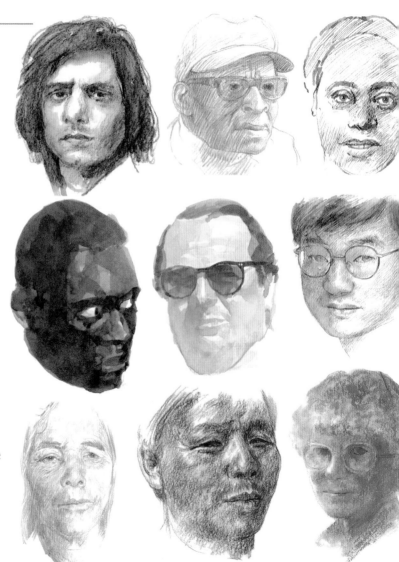

(Facing page) Drawings showing a variety of techniques

Watercolour pencil
After the features have been freely drawn with pencil, the skin tone and dark hair are implied with washes *(top left)*.

Graphite pencil
A linear and hatched style of drawing, using a relatively soft pencil *(top centre and bottom left)*.

Pen and ink
A bold and simple sketching style in sepia with hatching *(top right)*.

Brush drawing
Coloured washes are overlaid to create the colour and mass *(centre row, left and middle)*.

Pen and ink with wash
Delicate pen crosshatching with watercolor washes *(centre row, right)*.

Charcoal
Soft charcoal modelled and blended with a paper stump *(bottom row, right)*.

Coloured chalk
The textured paper suggests reflected light in this tonal study *(bottom row, centre)*.

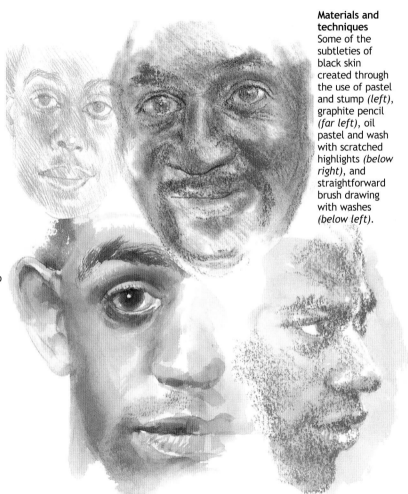

Materials and techniques
Some of the subtleties of black skin created through the use of pastel and stump *(left)*, graphite pencil *(far left)*, oil pastel and wash with scratched highlights *(below right)*, and straightforward brush drawing with washes *(below left)*.

Mature, time-worn faces are fascinating subjects to draw, and older people usually make extremely good models. They are often prepared to sit patiently while you make painstaking drawings and, provided you are able to chat and draw at the same time, may enjoy both your companionship and the novel experience of modelling.

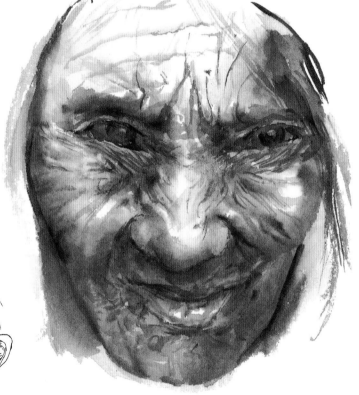

Elderly heads
Pen and ink (*left*)
Brush and sepia wash (*above*)

Bringing out the character
An older face can tell you much about a person and the kind of life they have led. Folds, lines, and veins are much more prominent, so use these features to bring out the character of your model.

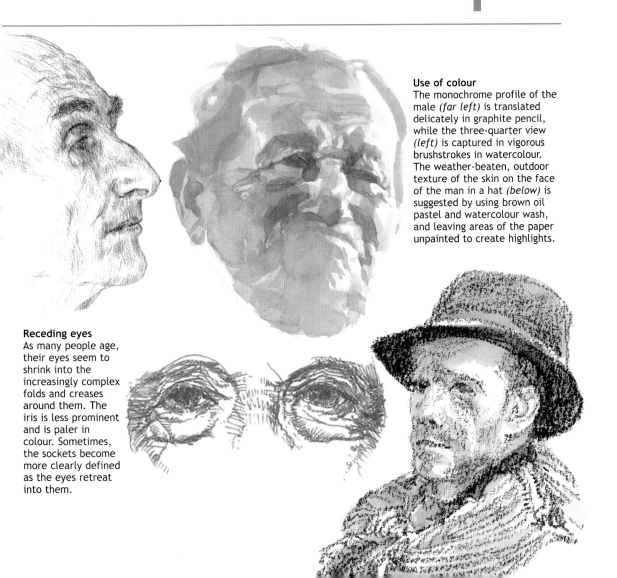

Use of colour
The monochrome profile of the male *(far left)* is translated delicately in graphite pencil, while the three-quarter view *(left)* is captured in vigorous brushstrokes in watercolour. The weather-beaten, outdoor texture of the skin on the face of the man in a hat *(below)* is suggested by using brown oil pastel and watercolour wash, and leaving areas of the paper unpainted to create highlights.

Receding eyes
As many people age, their eyes seem to shrink into the increasingly complex folds and creases around them. The iris is less prominent and is paler in colour. Sometimes, the sockets become more clearly defined as the eyes retreat into them.

Drawing hair is fun; it is a tremendously varied subject, and presents all sorts of technical and artistic challenges. The one thing you do not want is to produce a three-dimensional face and then to flatten the whole effect by drawing two-dimensional hair. The correct choice of medium can be crucial in this artistic process.

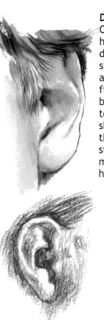

Drawing long hair
One way to depict long, shiny hair (*right*) is to apply a dragged wash, using a slightly damp brush. The artist knew that the fine bristles on the brush would splay out to create the linear shadow effect, and that long brush-strokes would mimic the flowing hairstyle.

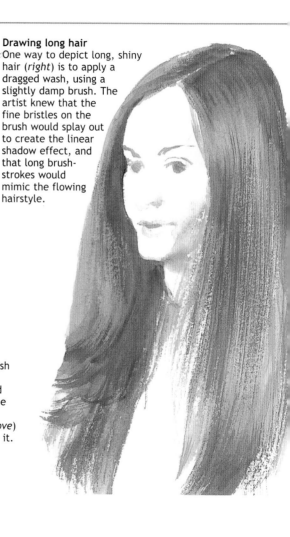

Hair and ears
Sideburns and longish hair (*top and left*) throw shadows, and partially obscure the ear. Hair tucked behind the ear (*above*) tends to emphasize it.

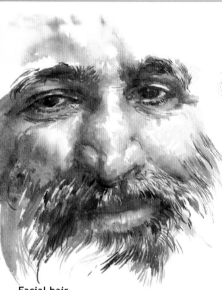

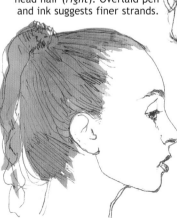

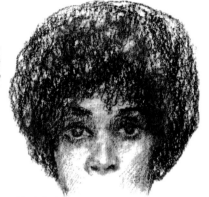

Hair styles
Hair can be piled up, cut, and arranged in many different ways for visual interest and variety.

Dark hair
Even in very dark hair, there are shadows and highlights that help describe the form.

Using two media
A wash blocks in the mass of head hair (*right*). Overlaid pen and ink suggests finer strands.

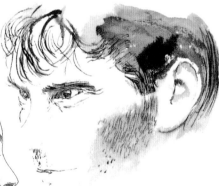

Facial hair
The direction of hair growth may distort the appearance of a model's mouth. Draw beards or moustaches with care. Also observe the beard-growth shadow on the male face (*below*). This provides additional colour and texture.

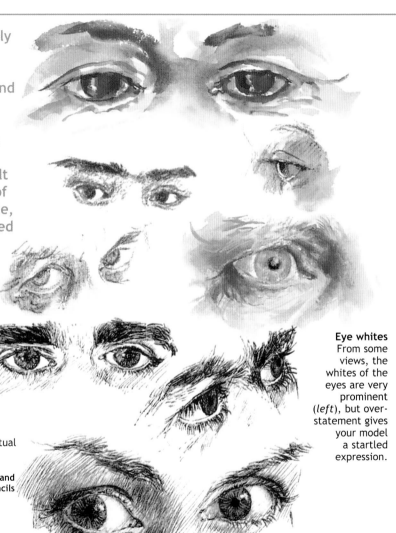

Because we instinctively use eye contact as a means of communication, many artists tend to overestimate the importance of eyes in comparison to the rest of the face when drawing. This can result in the eyes being out of proportion, for example, or becoming overworked and fussy.

Pairs of eyes
Make sure that both eyes track together as a pair. Depending on the angle of the head, the positions of the irises may not exactly correspond, but it will be obvious when eyes do not appear to be focusing together.

Reflected light
Accurate placing of reflected light in the eyes is absolutely essential (*top*), and should be related to the position of the actual light source.

Preliminary studies, using washes and a variety of pencils

Eye whites
From some views, the whites of the eyes are very prominent (*left*), but over-statement gives your model a startled expression.

The mouth is extraordinarily expressive, and is a remarkable vehicle for conveying the model's character. An accurate portrayal of the mouth, within the overall shape of the face, is a key factor in catching a likeness.

Not all mouths are symmetrical
Do not assume that a person's lips are perfectly regular. The asymmetrical or lopsided nature of some mouths is both fascinating and a challenge to draw.

Materials
Because graphite pencil is so expressive, it can be used to suggest a variety of textures. A smooth medium, such as brush and wash, portrays the glossy surface and hues of lipstick or wet lips effectively.

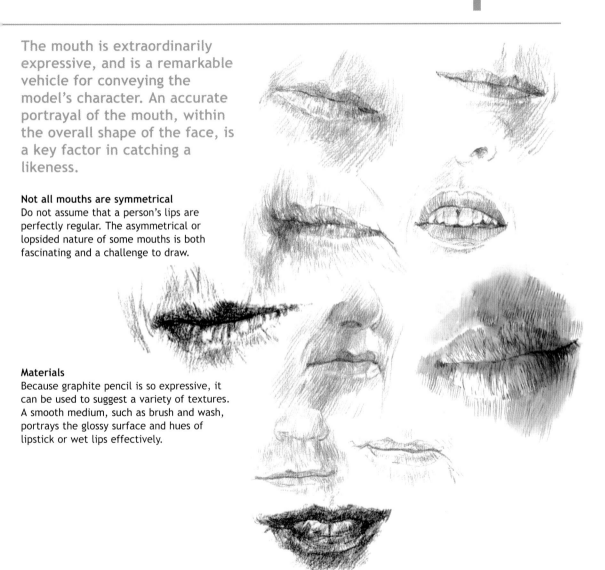

Because they are so complex, drawing ears is often one of the more difficult aspects of portraiture. Each person's ears are so distinctive, they demand careful consideration if you want to achieve a convincing likeness.

Individuality
No two ears are exactly alike, even on the same head. Before you draw someone's finished portrait, it may help to make preliminary studies of their ears. Are they prominent, neatly tucked in, small, or large? Note that a pair of ears are rarely on the exact same level.

Exploiting tonality
Using a medium such as wash (*right*), charcoal pencil (*centre*), or oil pastel (*far right*), gives you the opportunity to exploit tonality and to suggest depth, particularly on textured paper.

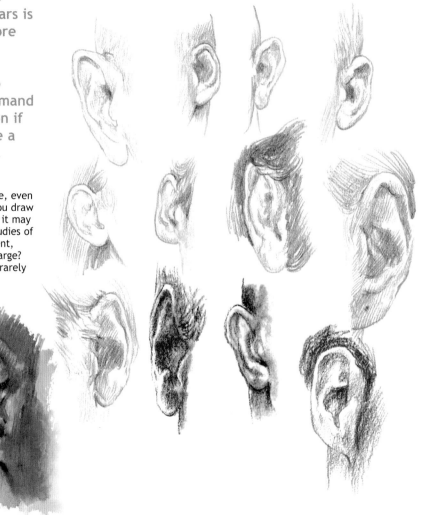

Inexperienced artists are often anxious about drawing noses. Experiment with materials, techniques, and viewpoints to show how a nose stands out from the face. Here, a variety of techniques is used: watercolour wash, bold pastel, and fine pencil line.

Nose contours
The shape of a person's nose is not directly related to the skull, and there is enormous variation in nose size, shape, and skin texture. Here, the highlights along the ridge of the nose and just above the nostrils give the nose a three-dimensional quality.

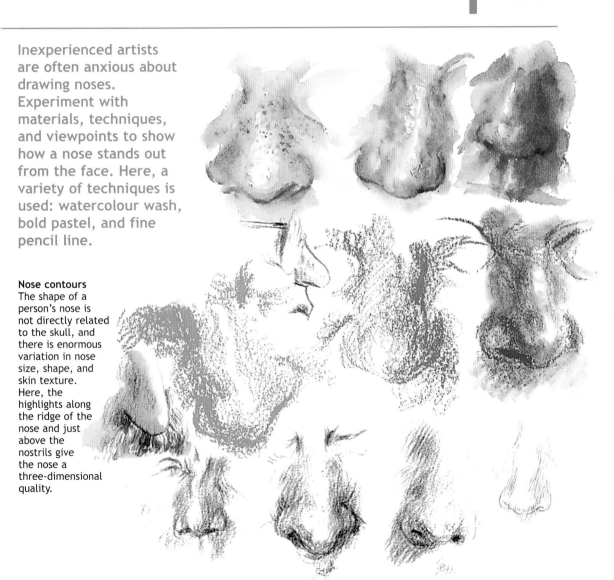

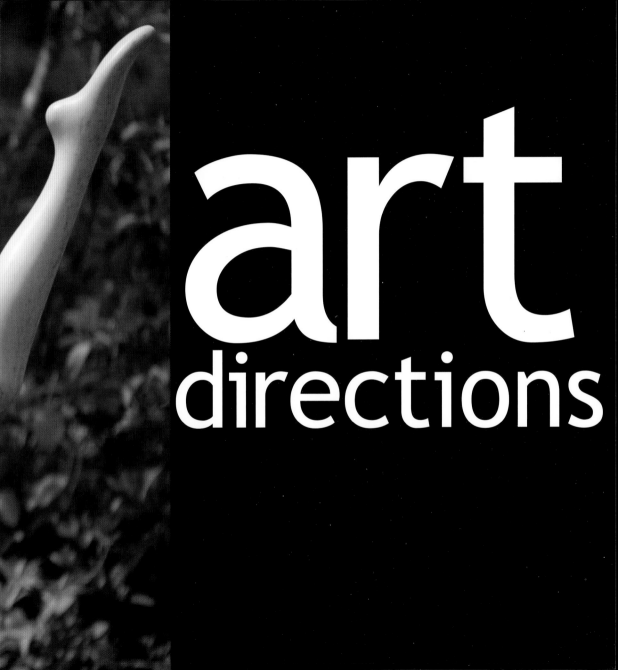

art
directions

Paper cuts

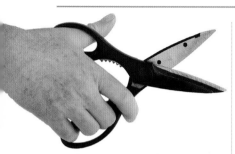

In these images the artist cut simple shapes out of paper to represent parts of the human form. These parts were then placed on the glass bed of a photocopier; you will find a computer scanner serves equally well. A sheet of black paper was then placed over the parts and a copy was made. As the parts are not glued down or fixed to a surface they can be moved around to create a variety of image variations. By using good quality paper and decent archival inks you can make a limited edition of prints from the same simple kit of body parts.

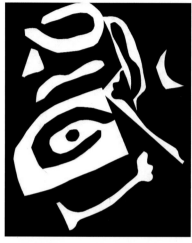

Kit of parts
A random arrangement of cutout shapes depicting facial features such as nose, eyes, and lips (*left*), may then be arranged more formally to create a simple graphic face (*below*). A similar kit of parts, with heads and limbs, is used to make the figures (*opposite*).

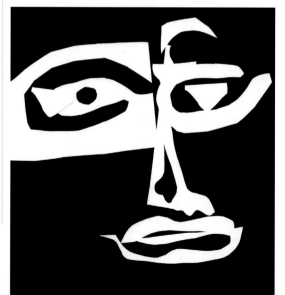

Prints from paper cutout shapes
(*this page and opposite*)
White cartridge paper and black card on photocopier bed
Editions of ten
Original size A4 (297 x 210mm, 11¾ x 8¼in)

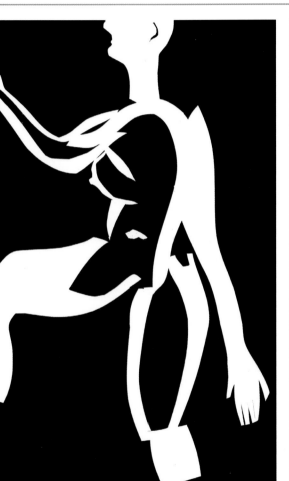

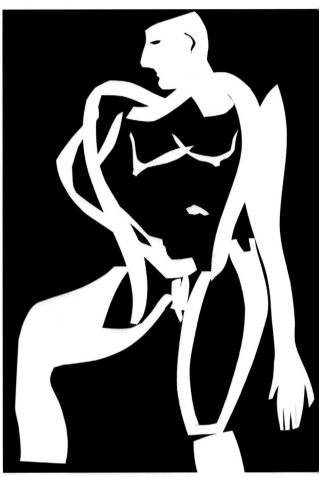

In depicting the human form in three dimensions this artist has fused two distinct themes of his work. The conventions of observational drawing and painting have been combined with one of his favourite sculptural motifs: underlying mechanics and structures. Often using found materials, the resulting work portrays the figure as a complex tracery of spars, beams, and frames on a machine-like armature.

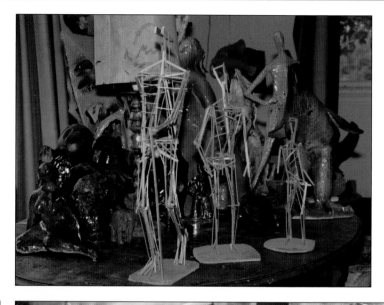

Tim Riddihough
Armature figures
Wood, cardboard and glue
2006

(*Left and below*) Three-dimensional figurework in wood and ceramics; the artist Tim Riddihough at work in his studio

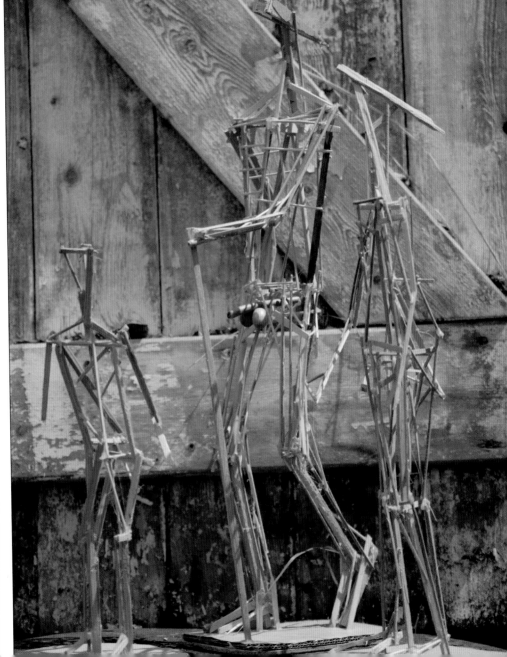

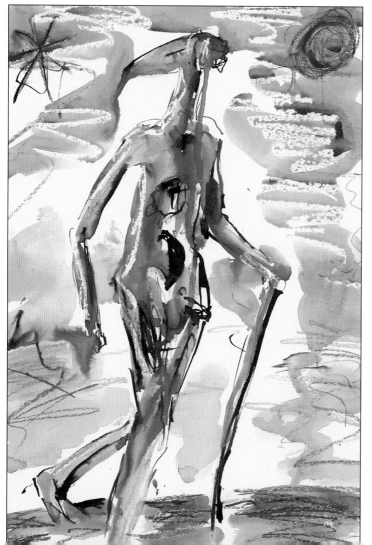

Tim Riddihough is an artist who works on diverse subjects. Among these is the human figure, which he interprets in both two and three dimensions in a variety of media. Shown here and opposite are three mixed-media drawings based on three-dimensional work.

☛ On the following pages are more examples of the artist's three-dimensional, mixed-media experimentation using found objects and materials.

Tim Riddihough
Figure studies, 2006
Abstracted from three-dimensional
work *(left and below)*
Mixed media on paper

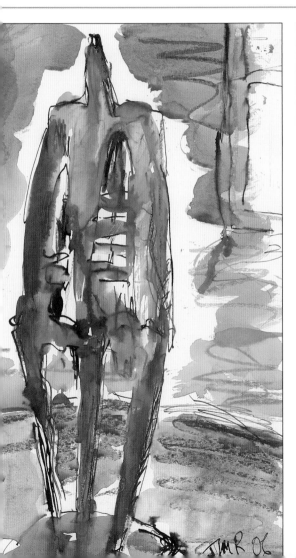
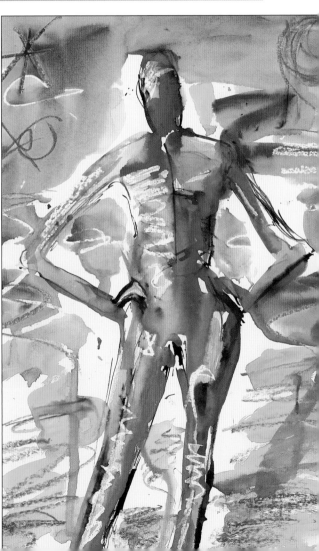

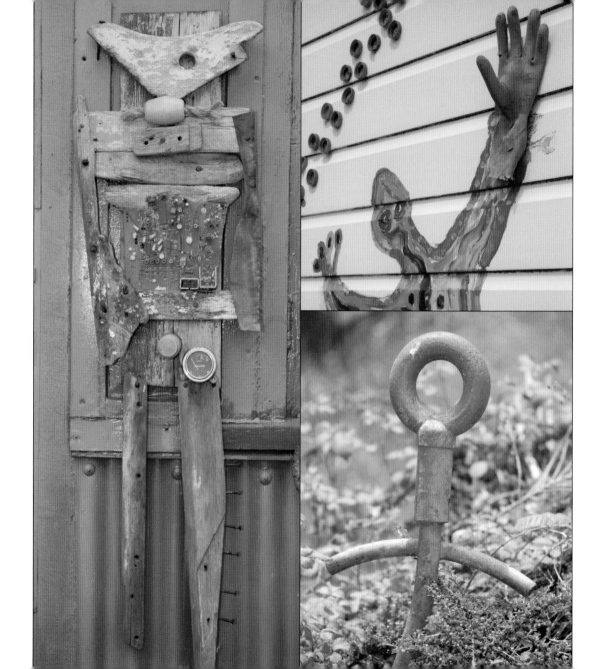

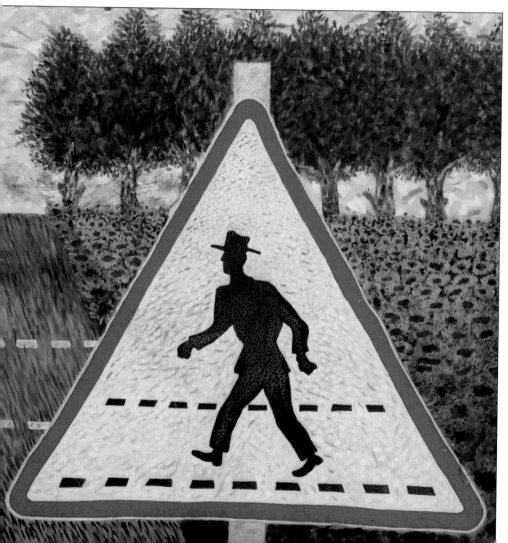

Paintings based on road signs
The artist used images from French road signs *(right)* to create a series of graphic-inspired figure paintings in the pop-art style *(left and below)*.

School Crossing
(above and detail far right)
Acrylic on canvas
71 x 71cm
(28 x 28in)

Pedestrian Crossing *(left)*
Oil on canvas.
152.5 x 152.5cm
(5 x 5ft)

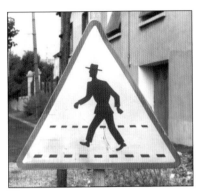

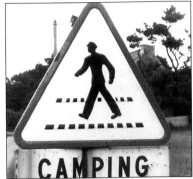

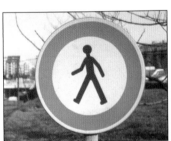

Before the widespread adoption of an international style for road signs, with a simple graphic portrayal of the human form, signs varied in style and character from country to country. The artist was fascinated with the figurative stylization on these French signs, many of which can still be seen in remote areas to this day.

Graphics of the human form
There is similarity of style in these French graphic interpretations of the human form. The lady on the packaging (*left*) seems to be eerily related to the people on the crossing signs.

Kerry Day
Square, Purple Nude No. 6 2007 (*right*)
Oil on canvas, 100 x 100cm (39 x 39in)
Reclining Nude No. 2 2007 (*detail, below*)
Oil on canvas, 61 x 45cm (24 x 18in)

"The human figure is unpredictable and constantly changing. My work is not about trying to get a likeness of the model; it is about being absorbed in the process of painting, and what I can do with it. I cannot really explain what I do, I just start painting. I guess I do have a considered technical approach, but I still get in a mess. My aim is to make even bigger canvases and to be able to walk up to them and give them a squeeze."

Kerry Day's painting focuses on the human body, particularly the nude. Her latest series of works are of bold, tightly cropped figures executed on large, square canvases, confidently dissecting the picture plane to create solid and often graphic compositions.

These substantial images of living, human flesh are undeniably figurative in content, yet present the viewer with large passages of abstract shape, colour and imagery. Drawing is crucial to their success. The artist commences the work by standing well back from the subject and the canvas, which has been primed in dark red. This colour has a significant influence on the warmth of the final flesh tones and, as she leaves a lot of the red-primed canvas showing, the look of the completed picture.

She draws in the figure using charcoal taped to a metre-long (3ft) stick. This drawing is constantly modified. Through this foundation of solid, drawn elements Kerry Day says she attempts to absorb the inherent life and movement of the living human form. Once the figure composition is established, the work progresses from charcoal to brush drawing, using a special mix of dark, easy-flowing, thinned oil paint.

The artist then proceeds to broad brushwork that enables her to explore the stillness of the subject, the light, the colour, and the atmosphere: "I like to keep a conscious element of drawing showing in my painting. It is important for me to avoid confusion and to keep my colours clean and separate to create a vibrancy on the canvas."

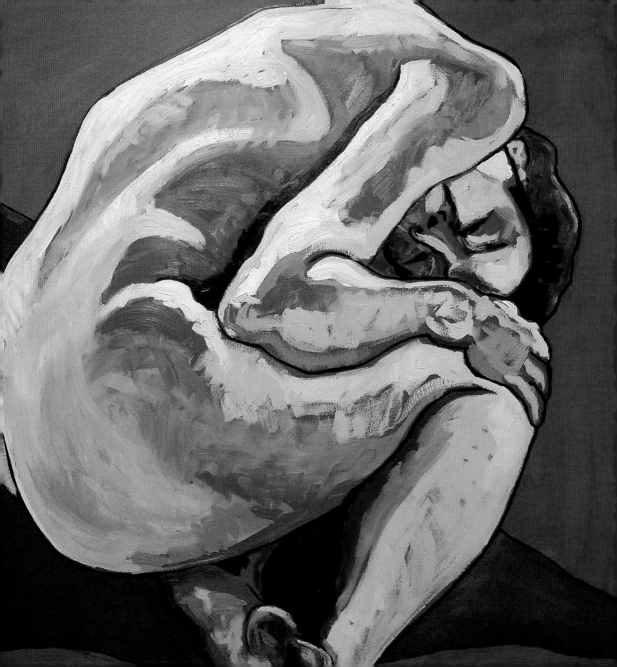

Intuitive, moving marks

Tarn Clogstoun has worked in metal and wood, forging and cutting these heavy-duty materials in order to manipulate and arrange them into intuitive and abstract three-dimensional forms. Life drawing was an intrinsic part of her training, and figurative elements informed her earlier bronzes and sculptures. Her recent works on paper focus on the human form, and these drawings demonstrate the physicality and versatility of materials used in her earlier

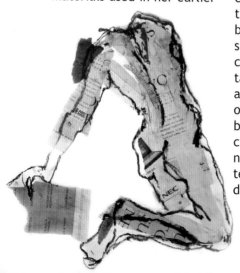

sculptural works, but remain recognizable human figures.

When making these graphic works Clogstoun absorbs herself fully, for just three minutes or so, in her model. Music plays as the model moves around the studio. This constant musical rhythm enables the artist to break away from her preconceptions about the drawing and may influence her linework to the point that shuddering, seismographic marks emerge. She seldom looks at the work as it progresses, but intuitively feels for shape and form, letting her concentration on the model take over. She works fast and furiously with a variety of media – quill pens, ink, brushes, water-soluble crayons, paste and newspaper – collaging, tearing and pasting, and drawing. Tarn Clogstoun is

not concerned with how an arm or leg should be, nor how it will appear in the finished drawing. She constantly modifies her approach, experimenting with technique throughout the drawing session.

The artist may draw with either hand, or even use her feet and fingers. She finds these methods and range of materials give her absolute freedom, even though this intuitive method of working is a hit and miss process in which, Clogstoun says, she may also create a "lot of rubbish". But her drawings reveal considerable control and accuracy, as she herself points out. "The model had dark hair, and I notice the heads and even the pubic areas are black. I had no consciousness of colour when I was doing them."

Tarn Clogstoun
Moving images
Mixed media and collage on paper
(*inset detail, below*)
71 x 48cm (28 x 19in)

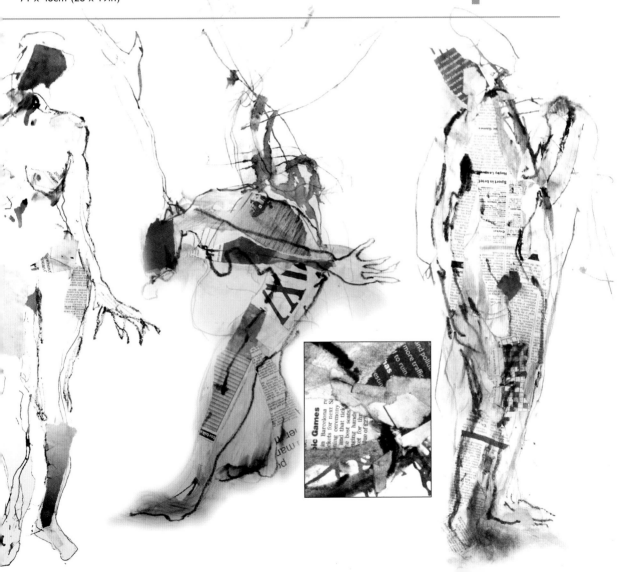

general
reference

Photographs are acceptable as artists' reference material, provided you use them as you would use sketches, and not as an end in themselves. A good photograph is a creative two-dimensional image in its own right, and a straight copy is not going to bring anything to it; in fact, the photograph will probably be better.

Abstract flesh (*left*)
Collage and paint in sketchbook

When to use photographs
Photographs are especially useful in situations when there is very little time for drawing – such as when working with an active child, for example. Always try to make a few sketches at the same time, to augment your photographic record, and take as many shots as possible from different viewpoints during the session. The sketches will tell you something about the three-dimensional nature of the living person, while the photographs will capture the things you may not be able to include in quick sketches, such as textures and small details.

Beware of distortion
When taking your own reference photographs, do not forget that camera lenses distort, particularly wide-angle lenses. This is the type of lens often used in digital cameras, and you will need to adjust your drawings accordingly.

Building a reference library
If you are interested in particular themes for your drawings, it pays to build a reference library, comprising your own photographs, with cuttings from newspapers, magazines and brochures. This will provide you with a rich variety of viewpoints, lighting conditions, and people to draw upon.

Advantages of photography
Photography may be your only realistic alternative for that particularly hard-to-find pose. It can freeze a fleeting movement into a ready-made two-dimensional image. Many professional illustrators use digital cameras, scanners, and computers for quick and reliable results.

Tracing photographs
Tracing from a photograph may seem like an easy way to make a drawing, but it does not necessarily lead to an accurate representation. Although it may be entirely convincing as a printed photograph, the same image may look distorted when reduced to a drawn outline. This is most often the result of lens distortion, which artificially stretches or foreshortens an object in camera. As a result, when using photographs for reference, you must be willing to make alterations to achieve correct proportions.

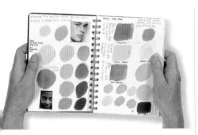

The importance of the sketchbook
Build a library of sketchbooks with visual information extracted from newspapers and magazines as well as your own drawings *(see page 38)*. Use these observations and notes as additional reference to help inform and complete drawings you are working on.

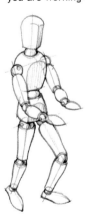

Lay figures
You may find it useful to use a wooden lay figure, or artist's manikin *(see page 30)*, as sold in art supply stores, to help work out a pose where people's actions were too fast for you to capture their movements in their entirety.

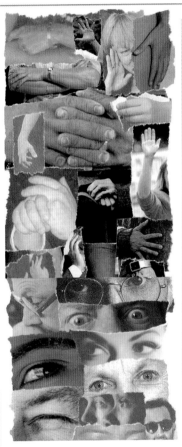

Visual reference library
Use images from a variety of printed matter to build up a picture library.

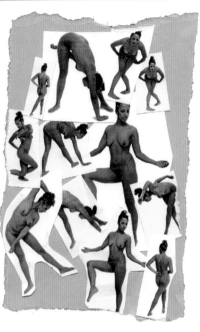

Hard-to-hold poses
Photography can capture spontaneous and sudden movements that you may not be able to include in an instant sketch. It offers confirmation of how the body balances when in motion.

210 Glossary of materials

The only essential equipment you need for drawing is a pencil and a piece of paper. But, as your experience grows and your skills develop, you will hopefully discover your own drawing style and maybe even move on to colour work and painting. As this happens, you will probably develop a preference for using particular art materials. Throughout this book you will have seen references to a variety of art terms, materials, and techniques, some of which may be new to you. The following is a glossary of useful information that relates to the artwork featured in this book.

Graphite pencil
The common "lead" pencil is available in a variety of qualities and price ranges. The graphite core (the lead) is encased in wood and graded, from softness to hardness: 9B is very, very soft, and 9H is very, very hard. HB is the middle-grade, everyday, writing pencil. The H-graded pencils are mostly used for technical work. For freehand drawing work, choose a pencil from around the 2B mark.

Graphite sticks
These are made of high-grade compressed and bonded graphite formed into thick, chunky sticks. They glide smoothly across the surface of the paper, lending themselves to bold, expressive drawing. You can vary the marks by using the point, the flattened edge of the point, or the side of the graphite stick.

Charcoal
Charcoal drawing sticks, made from charred willow or vine twigs, are available in three grades: soft, medium, and hard. Soft charcoal, which is very powdery, is ideal for blending and smudging; the harder varieties are better for linear drawing. When made into pencils, charcoal is cleaner to use and more controllable.

Charcoal pencils
Charcoal pencils are thin sticks of compressed charcoal encased in wood. This means they are cleaner to handle and easier to control than stick charcoal. They have a slightly harder texture and only the point can be used, so they are not ideal for creating large areas of tone. Charcoal pencils come in hard, medium, and soft grades. The tips of the pencils can be sharpened, like graphite pencils.

Coloured pencil
This is a generic term for all pencils with a coloured core. There is an enormous variety of colours and qualities available. They also vary in softness and hardness, but, unlike graphite pencils, this is seldom indicated on the packet.

Watercolour pencil
As above, except water-soluble and capable of creating a variety of "painterly" effects, either by wetting the tip of the pencil or working on dampened paper.

Conté crayon
Often known as Conté pencil, this is available in pencil or chalk-stick form. Originally a proprietary name that has become a generic term for a synthetic chalk-like medium, akin to a soft pastel or refined charcoal. It is available in black, red, brown,

and white, but is best known in its red form. Conté is a traditional and well-loved drawing medium.

Pastels

Pastels are drawing sticks made by blending coloured pigments with chalk or clay and binding with gum. This type of pastel is relatively soft and brittle. Oil pastels, made using an animal-fat binder, are stronger and less crumbly. Both types of pastels are available in a very wide range of colours and tones, as are pastel pencils.

Pastel pencils

Pastel pencils are thin pastel sticks encased in wooden shafts, like pencils. They are clean to use as they do not break or crumble like conventional pastels, and they provide more control. Suitable for line sketches and small-scale work, they can be used in conjunction with hard and soft pastels.

Oil pastels

Oil pastels are produced by combining raw pigments with animal fat and wax; this makes them different in character from the more friable pastels, which are bound with gum. Oil pastels are known for their painterly texture; they make thick, buttery strokes and intense colours.

Drawing ink

There is a variety of inks available, from water-soluble writing (fountain-pen or calligraphy) inks to thick, permanent, and waterproof drawing inks. India ink is a traditional drawing ink; it is waterproof and very dense, drying with an interesting, shiny surface. Drawing inks are available in many colours, and they can be thinned down with distilled water for creating washes.

Steel-nib (dip) pen

The old-fashioned, dip-in-the-inkwell pen is a worthy and versatile drawing instrument. You may want to experiment with nibs for thickness and flexibility, but just a single nib can make a variety of line widths as you alter the pressure on the pen.

Sketching pens

Although they resemble ordinary fountain pens in appearance, sketching pens have flexible nibs (designed specifically for drawing) that deliver ink smoothly from prefilled ink cartridges to the drawing paper.

Fibre-tip pen

Fibre-tip pens come in a variety of tip thicknesses. The ink flows well and smoothly, and fibre-tips are useful for creating drybrush effects when the ink runs out.

Bamboo and reed pens

Many artists like to use bamboo or reed pens. These traditional pens make relatively broad and slightly irregular strokes, and this makes them ideal for bold line drawings. Some of the appeal perhaps lies in the pleasure derived from drawing with such a "primitive" instrument.

Paper

Paper varies enormously in type, quality, texture, manufacture, and price. It is graded from smooth to rough, and is either smooth (hot-pressed, or HP), medium (cold-pressed, or CP), or rough. The smoothness or roughness of a paper is known as the "tooth". For example, the tooth of a watercolour paper is generally more marked and rougher than that of a cartridge paper for drawing. The tooth of a paper influences the way that a medium reacts to it.

Paper stump

A paper stump, sometimes known as a tortillon or torchon, is a strip of paper twisted into a narrow cone. The point is used to blend and soften charcoal or pastel.

Erasers

You can rub out unwanted pencil marks and drawings with an eraser, and you can also use it to create highlights by lifting out areas of tone. Plastic or putty erasers are best; India rubber tends to smear pencil work and it can damage the paper surface. Putty erasers are very malleable; you can break off smaller pieces and manipulate them into any shape, including a point for lifting out.

Pigment quality:
Artists' colours v. Students' colours

All types of paint are available in two qualities. Artist-quality paints offer the widest range of colours combined with maximum colour strength. They contain a high concentration of pigment, which is very finely ground with the best-quality ingredients. Student-quality paints are made in larger quantities and the colour range is relatively limited, usually with less intense pigments, so they are cheaper than artists' quality colours.

Mediums

Mediums are added to paint to change its characteristics. Different mediums are needed for use with watercolour, acrylics and oil paints. *(See also Glossary of terms p.216).*

Oil paint

Oil paint is the traditional medium of choice for artists; it is slow to dry and is infinitely workable. It consists of dry pigments ground in a natural drying oil such as linseed, or a semi-drying oil such as safflower or poppy. It requires the use of solvents, such as turpentine or white spirit, to dilute the paint and clean up. Some brands of paint are matured and then remade with extra pigment to achieve the right consistency, but most are made with additives, such as stabilizers and driers, to improve stability and, in some cases, to improve the consistency of the paint.

Mediums for oil paints

There are several types of medium for oil paints – some are based on traditional recipes, others on modern laboratory research. These mediums are formulated in various ways to improve the flow of the paint, alter its consistency, or produce a matt or gloss finish. Some mediums are slow-drying; others contain agents to speed up the drying rate. A similar range of mediums is available for water-mixable oil paints.

Water-mixable oil paints

This type of paint is made from modified linseed and safflower oils. As a result, the paint can be thinned with water instead of the usual solvents. The appearance, consistency and working characteristics are similar to those of conventional oils. Water-mixable oils have practical advantages over traditional oils – they are quicker to clean up, water is cheaper than turpentine, and brushes can be washed with soap and water.

Oil-paint sticks

Oil-paint sticks offer the richness of oil colour, with the freedom and directness of drawing in pastels or charcoal. They are made by combining artist-quality pigments with highly refined drying oils, which are then blended with special waxes so that the mix can be moulded into stick form.

Watercolour paint

This is by far the most popular paint for amateurs, yet it can be notoriously difficult to use. Watercolour paints are made of very finely ground pigments bound with gum-arabic solution. The gum enables the paint to be diluted with water, allowing thin trans-parent washes of colour that will adhere to the paper. Glycerine is added to the mixture to improve solubility and prevent the paint from cracking. A wetting agent, such as ox gall, ensures the even flow of paint across the paper.

Watercolours are available in artists' or students' quality.

Mediums for watercolour
Gum arabic, ox gall and glycerine are constituents of watercolour paints; when used as additional mediums, they modify the working properties of the paint.

Gouache
The matt, chalky appearance of gouache and its opacity when dry are very different qualities from the transparency of watercolour – but both media use similar equipment and techniques. The best-quality gouache paints contain a very high proportion of pigment. The colours are therefore pure and intense, and they create clean mixes. The less expensive gouache colours, also known as poster paints, often contain an inert white pigment, such as chalk, in order to impart smoothness and opacity. Gouache paint is sold in tubes, pots and bottles.

Acrylic paint
Acrylic paints dry quickly through evaporation of the water contained in the binder. As the water evaporates, the acrylic-resin particles fuse to form a flexible and water-resistant paint film that does not yellow with age. Once dry, an acrylic painting on canvas can

be rolled up, stored and restretched years later, with less risk of the paint surface cracking. Another advantage is that the colours dry at the same rate. Like oils and watercolours, acrylics are offered in both artists' and the cheaper students' qualities.

Mediums for acrylics
When used alone, acrylic paints dry to a flat eggshell finish. However, adding an acrylic medium to the paint gives depth and brilliance to the colours. You can use other mediums to change the consistency and finish, to help thinly diluted paint maintain its adhesion, to improve the paint's flow and "brushability", and to control its drying rate. Add mediums to the paint a little at a time, and mix well with a palette knife. You can further dilute the paint with water. For an even result, always mix colours before adding a medium.

Liquid acrylics
Similar to brilliant-colour drawing inks, liquid acrylics flow well from the brush. They are supplied in bottles with dropper caps, and their consistency makes them suitable for wash techniques and fine-pen work. Liquid acrylics are usually made with an alkali-base resin, and you can remove them with a special alkali cleaner.

The subject of art has its own special terminology. Listed here are some of the more unfamiliar terms that you may come across.

Alla prima (Italian for "at the first") A technique in which the final surface of a painting is completed in one sitting, without underpainting. Also known as "au premier coup".

ASTM
The American Society for Testing and Materials. This is an internationally recognized independent standard for certain paint qualities, adopted by most manufacturers.

Atmospheric perspective
The illusion of depth created by using desaturated colours and relatively pale tones in the background of a painting. Also known as "aerial perspective".

Backrun
A dark irregular line of colour caused by water dispersing pigment particles in a laid wash. (*See also Bloom.*)

Balance
In a work of art, the overall distribution of forms and colour to produce a harmonious whole.

Bleeding
In artwork, the effect of a dark colour seeping through a lighter colour to the surface. Usually associated with gouache paint.

Blending
Smoothing the edges of two colours together so that they have a smooth gradation where they meet.

Blocking in
Applying areas of colour and tone with relatively broad brushstrokes.

Bloom
A roughly circular mark, similar to a backrun. Bloom is also a term for a cloudy white deposit on varnished surfaces that have been kept in damp conditions.

Body colour
Opaque paint, such as gouache, that has the covering power to obliterate underlying colour. "Body" also refers to a pigment's density.

Chiaroscuro
(Italian for "light-dark") Particularly associated with oil painting, this term is used to describe the effect of light and shade in a painting or drawing, especially where strong tonal contrasts are used.

Cockling
Wrinkling or puckering in paper supports caused by applying washes on a flimsy or inadequately stretched and prepared surface.

Collage
Artwork composed of pieces of paper, fabric or other items pasted onto a support or drawing.

Contre-jour
(French for "against daylight") A painting or drawing where the light source is behind the subject.

Crosshatching
Close parallel lines that crisscross each other at angles to model and indicate tone. (*See also Hatching.*)

Dead colour
A term for colours used in underpainting.

Diluents
Liquids, such as turpentine, used to dilute oil paint. The diluent for water-based media is water.

Dry brushing
A technique for applying the minimum of paint by lightly stroking a barely loaded brush across the surface of a painting or support.

Earth colours
These colours – umbers, siennas,

and ochres – are regarded as the most stable natural pigments.

Encaustic
An ancient technique of mixing pigments with hot wax as a binder.

Fat
Used to describe paints that have a high oil content. (*See also Lean.*)

Filler
In painting, the inert pigment added to paint to increase its bulk (also called "extender"); or the material used to fill open pores or holes in a support or ground.

Film
A thin coating, covering, or layer of paint or ink, etc.

Fixative
A solution, usually of shellac and alcohol, sprayed onto drawings (in particular, charcoal, chalk, and soft pastels) to prevent them smudging or crumbling off the support.

Flocculation
A grainy effect in paintwork caused by pigment particles settling in groups instead of dispersing evenly. (*See also Granulation.*)

Flop or flip
To turn over or reverse.

Format
The proportions and size of a support.

Fresco (Italian for "fresh")
A wall-covering technique that involves painting with water-based paints on freshly applied wet plaster. Also termed "buon fresco".

Fugitive colours
Pigment or dye colours that fade when exposed to light.

Genre
A category or type of painting, classified by its subject matter – still life, landscape, portrait, etc. The term is also applied to scenes depicting domestic life.

Gesso
A sealant mixture, usually composed of whiting and glue size, applied as a primer for rigid oil-painting supports.

Glaze
In painting, a transparent or semi-transparent colour laid over another, different colour to modify or intensify it.

Granulation
A specked effect caused by coarse pigment particles settling in the hollows of textured paper. (*See also Flocculation.*)

Grisaille
A monochrome painting in shades of grey, or a grey underpainting.

Ground/Ground colour
A specially prepared painting surface. Dilute or broken colour applied to a primed canvas or other support in order to reduce the glare from a white surface.

Hatching
A technique for indicating tone and suggesting light and shade in a drawing or painting, using closely set parallel lines. (*See also Crosshatching.*)

Highlight
High-key area of tone, created by light reflecting back from a surface.

Hue
The name of a colour – blue, red, yellow, etc. – irrespective of its tone or intensity.

Impasto
A technique of applying paint thickly with a brush or painting knife, or by hand, to create a textured surface. Also the term for the results of this technique.

Intensity
The purity and brightness of a colour. Also known as saturation or chroma.

Key
Used to describe the prevailing tone of a painting: a predominantly light painting has a high key, a dark one has a low key.

Lay figure
A jointed wooden manikin that, ideally, can be moved into almost any pose or attitude, for studying proportions and angles, and for arranging clothing and drapery. Lay hands and horses are also available.

Leaching
The process of drawing out excess liquid through a porous substance.

Lean
Adjective used to describe paint thinned with a diluent such as turpentine or white spirit, which therefore has a low oil content. (*See also Fat.*)

Lightfast
Term applied to pigments that resist fading when exposed to sunlight. (*See also Fugitive colours.*)

Linework
The linear elements of a picture, produced by drawing with a pen, pencil or paintbrush.

Local colour
The actual colour of an object or surface, unaffected by shadow colouring, light quality or other factors; for instance, the local colour of a lemon is always yellow, even with a blue shadow falling across it.

Medium
This term has two distinct meanings: (1) an additive (plural **mediums**) mixed with paint to modify characteristics such as flow, gloss or texture; (2) the material (plural **media**) chosen by an artist for working, such as paint, ink, pencil, pastel, etc.

Mixed media
In drawing and painting, this refers to the use of different media in the same picture (for example, ink, watercolour wash, and wax crayon), or to the use of a combination of supports (for example, newspaper and cardboard).(*See also Fresco.*)

Negative shapes
The shapes between and around the principal elements or objects in a painting. (*See also Positive shapes.*)

Patina
Originally the green-brown encrustation found on bronze, this term now includes the natural effects of age or exposure on a surface, such as old yellowing varnish on an oil painting.

Permanence
Refers to a pigment's resistance to fading on exposure to sunlight. (*See also Fugitive colours and Lightfast.*)

Pigments
The colouring agents used in all painting and drawing media. Traditionally they were derived from natural sources, but pigments are also man-made substances. The word is also used to describe the powdered or dry forms of the colouring agents.

Plein air (French for "open air")
Term describing paintings done outdoors, directly from the subject.

Positive shapes
The shapes created by the principal elements or objects in a painting. (*See also Negative shapes.*)

Primer
Applied to a layer of size or directly to a support, a primer acts as a barrier between paint and support. It also provides a surface suitable for receiving paint.

Proportion
The relationship of one part to the whole or to other parts. For example, this can refer to the relation of each component of the human figure to the figure itself or to the painting as a whole.

Recession
In art, this describes the effect of making objects appear to recede into the distance by the use of atmospheric perspective and colour.

Reduction
The result of mixing a colour with white paint.

Saturation
The intensity and brilliance of a colour.

Scumble
The technique of dragging one or more layers of dryish opaque paint over a bottom layer that partially shows through the overlying ones.

Sfumato (Italian for "shaded off")
Gradual, almost imperceptible transitions of colour, from light to dark.

Sgraffito (Italian for "scratched off") Scoring into a layer of colour with a sharp instrument, to reveal either the ground colour or a layer of colour beneath.

Shade
Term for a colour darkened with black.

Sketch
A rough drawing or a preliminary draft of a composition, not necessarily to be worked up subsequently. Sketches are often used as a means of improving an artist's observation and technique.

Study
A detailed drawing or painting made of one or more parts of a final composition, but not of the whole.

Support
A surface used for painting or drawing – canvas, board, paper, etc.

Thixotropic
A property of stiff fluids that become liquefied when stirred, shaken, or brushed.

Tint
Term for a colour lightened with white. Also, in a mixture of colours, the tint is the dominant colour.

Tooth (or grain)
The surface texture, ranging from coarse to fine, of painting supports.

Trompe l'oeil
(French for "deceive the eye")
A work of art – for example, a still life with extreme naturalistic details – that aims to persuade the viewer that he or she is looking at actual objects rather than a two-dimensional representation.

Underpainting
An early stage of a painting (sometimes in monochrome) used to establish the composition, overall tone, and colour balance. Also known as "laying in".

Value
The term "tonal value" refers to the relative degree of lightness or darkness of any colour.

Volume
The space that a two-dimensional object or figure fills in a drawing or painting.

Wash
A thin, usually broadly applied, layer of transparent or heavily diluted paint or ink.

Wet-in-wet
A watercolour technique for mixing two or more colour washes on a support before the washes have had time to dry.

Wet-on-dry
A watercolour technique for applying a wet wash over another that has already dried on the paper.

In the life class, pages 51-83

(at The Art House, London)

Tutor:

Stephen Palmer
Contributing artists
in alphabetical order:

Paul Clinton

Maureen Coyle

Laura Doehler

John Hopewell

Hannah Moss

John Quiddington

Tim Ralston

Adam Taylor

Dora Tuttiet

Ben Varney

Sarah White

Many thanks to the tutor, Stephen Palmer, and the students and life models of the life class held at The Art House, London, for their generous contributions.

In the studio, pages 85-126

(at Marina Studio, East Sussex)

Artist:

Robin Holtom
Many thanks to Robin Holtom and his life model for their generous contributions.

Photography

All studio photography, location and model reference photography by
Ben Jennings
Many thanks to the life models of The Art House and Marina Studio who gave generously of their time.

© The copyright in the images reproduced in **Body Parts**, *a practical source book for drawing the human form*, remains with the individual artists, illustrators, photographers, organizations and/or their successors, and is reproduced here by prior arrangement and/or kind permission. The editors and producers of **Body Parts**, *a practical source book for drawing the human form*, have attempted to contact all copyright holders of material published in this book. In case of any errors or omissions, please contact the publishers for rectification in subsequent editions. *Some of the material in this book first appeared in The Ways of Drawing Series Inklink © 1993, © 1994*

Picture credits/image sources

All images are identified in the following listing by **Section** and page number (p.)

The human machine

Coral Mula (p.11 & 12); Val Wiffen (p.12, 13, 15, 22, 23, 26, 28); Michael Woods (p.17); Inklink (p.24, 27, 29, 31); Brera Gallery, Milan (p.25); Munich, Antiquarium (p.24); National Gallery, London (p.25); *The Nude*, Sir Kenneth Clark, John Murray 1956 (Albrecht Durer p.28 & Raphael's *Leda* p.29); *The Household Physician*, Gresham Publishing Co. 1932 (p.39); Michael Oliphant Collection (p.32); Global Arts (p.31 & 33).

Starting points

Leslie Harris (p.36-7); Simon Jennings (p.38-9); Val Wiffen (p.40, 42-3, 44-5, 46-7); Victor Ambrus (p.44); Inklink (p.44).

In the life class

Tim Ralston (p.54 & 59); Sarah White (p.56); John Hopewell (p.56 & 67); Paul Clinton (p.57); John Quiddington (p.57); Ben Varney (p.56); Maureen Coyle (p.56); Hannah Moss (p.57 & 59); Laura Doehler (p.57); Dora Tuttiet (p.60); Adam Taylor (p.62 & 67).

In the studio

Robin Holtom (p.88, p.90-91, p.92, p.95, p.96-7).

Hands and feet

Michael Woods (p.132-3, 134); Inklink (p.130,134-5, 136-7, 138-9, 140-41, 142-3, 144-5, 146, 150-51, 153, 154-5); Val Wiffen (p.137, 145, 146, 147, 156-7, 158-9); Victor Ambrus (138-9, 142-3, 146-7).

Heads and faces

Michael Woods (p.174-5); George Underwood (p.174-5); Val Wiffen (p.174-5, 176-7, 178-9, 180-81,182-3, 184-5, 186-7, 188-9); Roger Coleman (p.179, 180, 182-3, 184-5).

Art directions

Tim Riddihough (p.190-91, 194-5,196-7); Kerry Day (p.202-3); Tarn Clogstoun (p.204-5); Simon Jennings (p.192-3, 200-201).

Body Parts
Created by Simon Jennings

First published in the United States by North Light Books an imprint of F+W Publications, inc.
4700 East Galbraith Road
Cincinnati, OH 45236
800-289-0963
www.fwbookstore.com

First published in Great Britain in 2007 by Mitchell Beazley, under the title *Body Parts* an imprint of Octopus Publishing Group Limited, 2–4 Heron Quays, Docklands, London E14 4JP
www.mitchell-beazley.com

Copyright © Simon Jennings 2007
Copyright © artwork, illustrations, and photographs remains with the originators 2007 (see page 223)

ISBN-13: 978-1-58180-974-9
ISBN-10: 1-58180-974-3

Conceived, edited, and designed by Simon Jennings at Auburn Studio.

Text editor Geraldine Christy
Photography Ben Jennings

Some of the material in this book was first published in *The Ways of Drawing* series (Running Press/Cassell-Studio Vista 1994).

Body Parts, *a practical source book for drawing the human form,* has been made possible by the goodwill and cooperation of many people, and represents the work of several hands and minds. The editors and producers are grateful to the following individuals and organizations for their valuable contributions to this book.

Main contributing artists
Val Wiffen
Victor Ambrus
Roger Coleman
Tarn Clogstoun
Kerry Day
Robin Holtom
Tim Riddihough
Michael Woods

Some of the artwork first appeared in The Ways of Drawing series Inklink © 1993, © 1994. Artwork © The Artists, see page 223.

Consultants
Robin Holtom, Marina Studio, *In the studio* section.
Stephen Palmer, The Art House, London, *In the life class* section.
Carolynn Cooke, *Art education consultant.*

Set in: Trebuchet MS
Colour reproduction by Spectrum Colour, UK
Printed and bound by Toppan, China